IMAGES
of Aviation

SOUTH DAKOTA'S
FIRST CENTURY OF FLIGHT

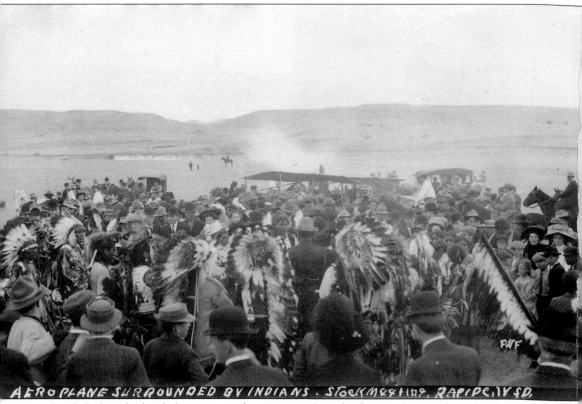

AEROPLANE SURROUNDED BY INDIANS. STOCK MEETING, RAPID CITY SD.

South Dakota had only been a state for 22 years when the first airplane took to the skies over Rapid City in 1911. This shows the meeting of two cultures, the Sioux Indians that had called this their home for centuries, and the more technologically advanced white culture that had taken their land away. (Courtesy of Minnilusa Historical Association at the Journey Museum.)

ON THE COVER: Notable men involved in aviation in South Dakota during the 1930s gather under the wing of the Ford tri-motor owned by Rapid Airlines. Fourth from the left is Capt. W. W. Spain, credited with the first cross-country flight in the state in 1919. Pilot of the Ford was Clyde Ice, 11th from the left. While various companies around the state called themselves "airlines," none provided the service that people today associate with scheduled service. (Courtesy of Luverne Kraemer.)

IMAGES
of Aviation

SOUTH DAKOTA'S
FIRST CENTURY OF FLIGHT

Norma J. Kraemer

ARCADIA
PUBLISHING

Copyright © 2010 by Norma J. Kraemer
ISBN 978-0-7385-8425-6

Published by Arcadia Publishing
Charleston, South Carolina

Printed in the United States of America

Library of Congress Control Number: 2009943875

For all general information contact Arcadia Publishing at:
Telephone 843-853-2070
Fax 843-853-0044
E-mail sales@arcadiapublishing.com
For customer service and orders:
Toll-Free 1-888-313-2665

Visit us on the Internet at www.arcadiapublishing.com

To Vern, whose J-3 Cub brought us together.

CONTENTS

ACKNOWLEDGMENTS

This book grew out of a paper about the 35 airports in the Black Hills that have come and gone since 1911 for a 2000 history conference. Most people I asked for assistance were gracious and enthusiastic in contributing.

My aviation partner, Luverne Kraemer, is possibly the best collector of the state's aviation history since he started his flying career in 1940. He is still flying the J-3 Cub he learned to fly in. His network of friends, especially Marion Havelaar, Cecil Ice, and Arnold Kolb, generously shared their collections and their personal knowledge of South Dakota aviation. Roberta Sago at Black Hill State University, Reid Reiner at the Minnilusa Historical Association, Lester Snyder of the Civil Air Patrol, Shari Theroux at Northern State University, and James Winker of Raven Industries were outstanding in their contributions. Jack Mitchell and Jim Anez, both retired flight service station specialists, were generous in sharing what they had. The Black Hills National Forest's Beth Steinhauer was generous as well as their pilots. The South Dakota School of Mines and Technology Institute of Atmospheric Sciences' Connie Crandall and Paul Smith were great stewards of their research. Paul Harwig of Horizons gathered his staff to give an oral history of the company. The South Dakota State Archives rolled out the red carpet for my days there. Al Fisher, Marion Havelaar, and Luana Hellmann Hill lent their expertise in proofreading.

There are some sources with titles so long they do not fit picture captions, so the following abbreviations cover their contributions:

Minnilusa Historical Association at the Journey Museum, Rapid City, SD (MHAJM)
Leland D. Case Library for Western Historical Studies, Black Hills State University, Spearfish, SD (LDCLWHS)
Center for Western Studies at Augustana College, Sioux Falls, SD (CFWSAC)
Beulah Williams Library of Northern State University, Aberdeen, SD (BWLNSU)
South Dakota State University Archives and Special Collections, Brookings, SD (SDSUASP)
Texas Woman's University Collection, Denton, Texas (TWUCDT)
South Dakota School of Mines and Technology Institute for Atmospheric Sciences, Rapid City, SD (SDSMTIAS)
South Dakota State University Aviation Program, Brookings, SD (SDSUAP)

INTRODUCTION

South Dakota's sparse population with large distances between people and places is a perfect environment for aviation to thrive. The centennial of flight in the state will be March 2011, and this book is to celebrate the inventive ways residents have pursued flight. When the first airplane took to the skies in western South Dakota in March 1911, people were still homesteading land claims within 100 miles of the flight. They usually arrived at their claims by horse and wagon. Yet that frail airplane would transform life for everyone in the state within a generation.

The first female pilot to fly in South Dakota, Nellie Zabel Willhite, was the daughter of one of the pioneer bull-whackers, Charles Zabel, on the Fort Pierre to Deadwood trail during the Black Hills Gold Rush. Nellie named her airplane after his nickname, "Pard," and flew her father along the route he walked so many times in her long-winged Alexander Eaglerock biplane. After the Rapid City to Fort Pierre leg of the flight, she flew her dad to his Sheboygan, Wisconsin, home. This was an ambitious trip for anyone in an airplane in 1928 with no aviation maps or radio navigation aids available. Unlike so many of Nellie's contemporaries, she died of old age at 96, instead of some mishap while in an airplane. Nellie represents the spirit of many pilots I have known in South Dakota over the years.

From 1911 to the end of World War I, flying was a novelty to people in South Dakota associated with public displays such as a fair or rodeo. No one seemed to think of it as a viable way to make a living. However, a few hardy souls learned to fly for the military in World War I and brought their love of flying home after the war. They continued to barnstorm at first, using surplus military aircraft. These airplanes were a leap in technology beyond the airplanes flown prior to the war. They even had a compass, although these were often considered an extra when buying an airplane.

While the first airplane to fly in Rapid City inspired the curious, Charles Lindbergh's air tour of the United States did the most to inspire South Dakotans to take aviation as a serious pursuit for business and pleasure. Sioux Falls did not want to miss out on his coming to town, so they made sure they had an airport at Renner. Charles Lindbergh did not even have to land to generate excitement. His course over the town of Huron was celebrated in the newspaper as if they had seen the space shuttle fly over. Next the U.S. Post Office kept local towns accountable for the quality of the airport available for airmail deliveries. Several towns resisted for a long time spending money on a decent airport, but all finally relented. Before the post office insisted on quality airports, privately owned and operated airports offered a mixed assortment of facilities that brought out greed in some entrepreneurs. The scheme of the Halley brothers in Rapid City to control airports across the country ended in failure.

World War II gave a solid footing to aviation in the state even before the war started with the Civilian Pilot Training Program. After Pearl Harbor, towns could not offer their airports to the military fast enough for them to come to town and train airmen across the state. The U.S. Army Air Corps left behind great runways and facilities that many towns inherited. One town has kept

its military base for over 60 years: Rapid City. It has helped take the town from a sleepy little cow town of 3,854 souls in 1910 to a metropolitan area with a population of 120,279 as of 2007.

Pioneer aviator Clyde Ice represents the willingness of South Dakotans to be self-reliant. After teaching himself to fly, he started as a barnstormer and is responsible in large part for aviation's success in the state. He was still crop dusting into his 80s and passed on his love of flying to his sons. He tried repeatedly to earn the air mail contract in the 1930s, only to lose to out-of-state interests. He flew the mail daily from Spearfish to Minneapolis via Pierre, Huron, and Watertown for six months in spite of the challenges weather made and no navigation aids to help him find his way. Clyde tried just about everything possible with an airplane: wing walking, hauling passengers, carrying mail, delivering sick people to the Mayo Clinic, teaching military pilots, herding horses, and spraying crops.

South Dakota also embraces some less-than-traditional views of aviation, including lighter-than-air. The state started the U.S. space program, not with an airplane, but a balloon. Eventually Ed Yost of Sioux Falls made hot air ballooning available in an easy way for everyone.

While South Dakotans tend to be minimalists when it comes to government, they realize that the government's involvement makes our wide open spaces less a hazard to our health by reducing the time between places. The state has registered airplanes and pilots since 1935 and encouraged the building of the infrastructure to make flying safe. State-operated higher education institutions have taught pilots and mechanics since the late 1930s, yet respect the local airport operator's right to teach flying. They often work in partnerships.

Today people use aircraft for personal transportation, firefighting, air ambulance, tourism, and fun. Some people use the aircraft to meet personal challenges, such as air racing or aerobatics. Some love the challenge of building their own airplane and wonder what they are going to do once it is flying. Do they start another project? Perhaps fun is the best reason of all to fly. South Dakotans have few restrictions on flying and have wonderful, wide open skies. Flying weather is usually very good, with very few instrument flight rules days. When the weather gets too bad to fly, I have even seen the ducks walking.

This book hits the highlights of aviation in South Dakota. It cannot be an all-inclusive history and should be considered a starting point for one's own exploration of the subject. Just because a person or town was not mentioned does not diminish that person's or town's contributions to the state's rich aviation history. This is a departure, not a destination.

One

AVIATION COMES TO
SOUTH DAKOTA

South Dakotans made their first tentative explorations of the skies by balloons and airships in 1882. The first heavier-than-air machine took to the air in 1911 because of the vision of a small town in western South Dakota, when the South Dakota Stockgrower's Association in Rapid City hired the Curtiss Exhibition Company to be the main attraction for its annual meeting. People from all over the region clamored to see a technology that would transform the world.

That first series of flights inspired groups and individuals to explore aviation. The Rapid City event was so successful, the South Dakota State Fair hired three pilots and their planes to appear that year. However, until South Dakotans began learning to fly with the military, aircraft were mostly seen at public exhibitions, not owned for personal use.

Saxe Pitts Gantz has the distinction of being the first South Dakotan to learn to fly. He asked Frank Robinson, the Curtiss demonstration pilot, where he could learn and then traveled to Missouri and built his own version of a Curtiss airplane for $3,000. After demolishing it on his first flight past the "grass-cutting" phase, he rebuilt it and then earned $800 at a county fair in Breese, Illinois, in August 1911. The plane was destroyed in a shop fire the night he received a telegram telling him his mother had died in Rapid City. Saxe returned home and never rebuilt the plane.

The second South Dakota pilot was Frank Aukerman of Sturgis. Like Saxe Pitts Gantz, Frank was at the Rapid City demonstration in 1911. Frank learned to fly at the Curtiss school in Hammondsport, New York. In 1916, Frank and his brother, Burt, bought a Curtiss "pusher" at Hot Springs from a financially troubled touring pilot, Andrew Hartman. Unfortunately when Burt tried to solo the plane, he destroyed it in South Dakota's first airplane crash.

The potential for the use of the airplane would have to wait until after the Great War.

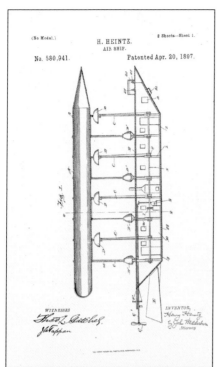

Before heavier-than-air flying machines came to South Dakota, one Elkton resident, Henry Heintz, patented an airship in 1897. He attempted to fly it on April 15, 1900, at Elkton, but newspapers reported the airship got up about 8 feet before plopping to the ground. Heintz incorporated the Northwestern Aerial Navigation Company in 1902, but the company was never heard of again. (Courtesy of U.S. Patent and Trademark Office.)

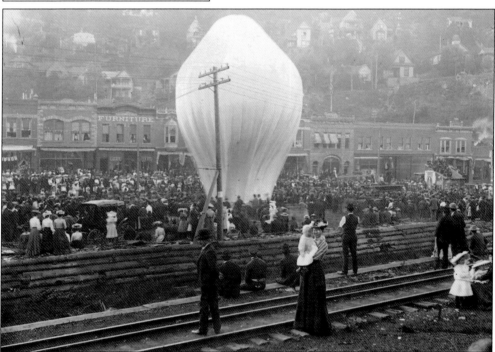

In 1903, this smoke balloon ascended over Deadwood, South Dakota. Balloons made rare appearances in South Dakota starting in 1882 at Custer. They were either hydrogen-filled or smoke balloons. The hydrogen was created by mixing sulfuric acid and iron filings. Smoke balloons were placed over a pit and heat from a fire was vented to the bag. (Courtesy of the Adams Museum.)

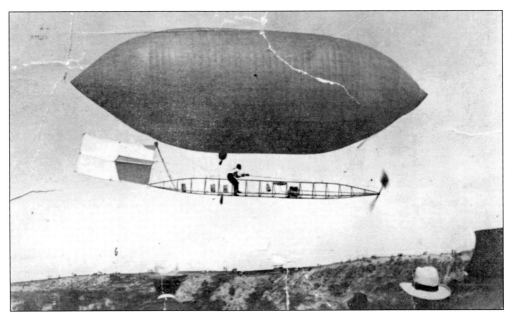

This postcard of an airship at the 1908 South Dakota State Fair at Huron is postmarked September 17, 1908. Addressed to Grant Troxel, in Wagner, South Dakota, and sent by Tim Lang, it reads: "Grant this is the way the air ship looked to me at Huron Faire. Gee but it was a dandy." (Courtesy of Luverne Kraemer.)

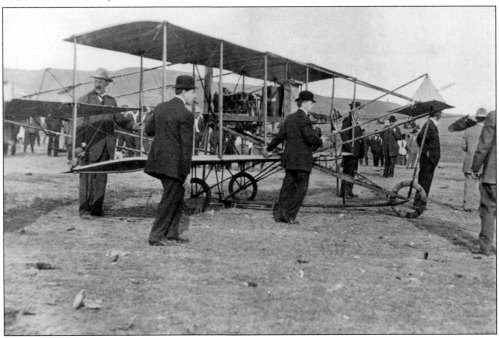

The Western South Dakota Stockgrower's Association hired the Curtiss Exhibition Company to make three demonstration flights at its convention in Rapid City, March 10–12, 1911. The Curtiss Model D was shipped to town by train and arrived on March 8. After assembly, pilot Hugh Robinson test flew it that day, breaking a wheel on landing that had to be repaired. (Courtesy of Luverne Kraemer.)

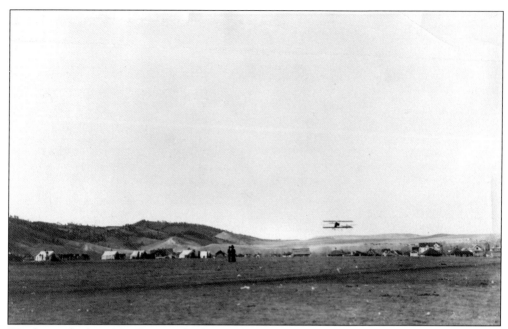

Winds were high on March 10, so the first public demonstration was delayed until March 11. The plane flew south of downtown Rapid City between Fifth Street and West Boulevard, approximately along the current path of Kansas City Street. The plane never flew higher than 400 feet. In 1911, the area was open prairie. The newspaper accounts report no "spectacular work" because of the unstable weather conditions. (Courtesy of MHAJM.)

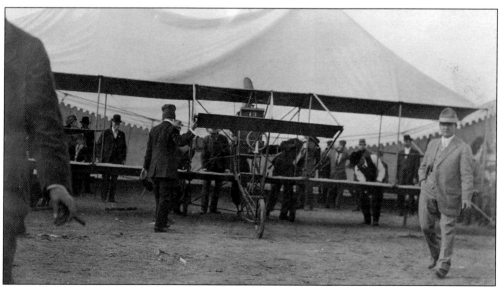

In this picture, pilot Hugh Robinson holds the forward stabilizer. Joseph B. Gossage, publisher of the *Rapid City Journal*, stands to the left of Robinson behind the plane. The contract for the Rapid City flight required construction of a 30-foot-by-40-foot tent or shelter for the public gathering. (Courtesy of MHAJM.)

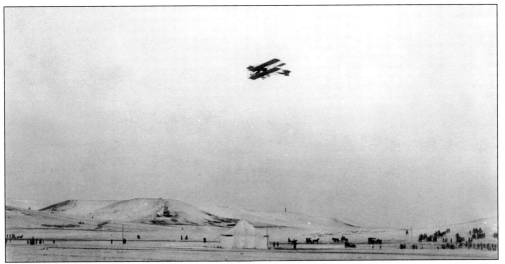

This view of the Robinson plane looks toward the east, showing today's Reservoir Hill. The aircraft shelter is shown below the aircraft. This flight occurred on March 12, 1911. It appears to have snowed during the Stockgrower's Convention. (Courtesy of MHAJM.)

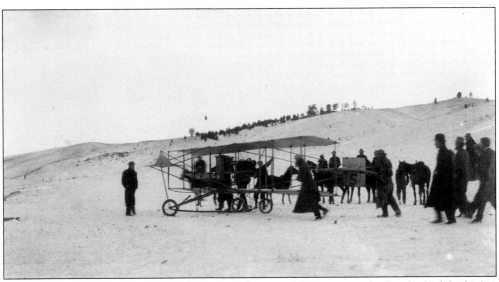

The 1910 U.S. Census recorded Rapid City's population as 3,854, compared to Lead, which had 8,394 residents. The Rapid City group that guaranteed the cost of the demonstration was very pleased with the flights; this picture shows the last landing on March 12, 1911. (Courtesy of MHAJM.)

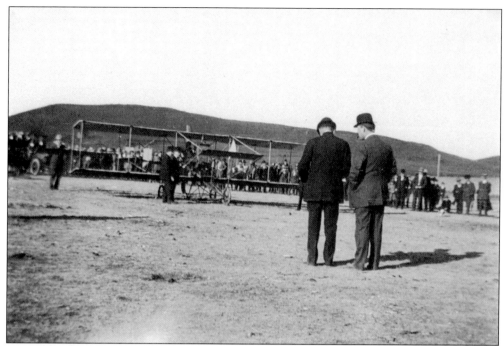

People traveled from all over South Dakota to see the flights. The town of Newell chartered a train to bring its residents and band to the convention. The train picked up people along the route and arrived in Rapid City with 500 people aboard, including their own band to entertain. Agnes Mead was from Central City. (Photograph by Agnes Mead, courtesy of grandson Ivan Hovland.)

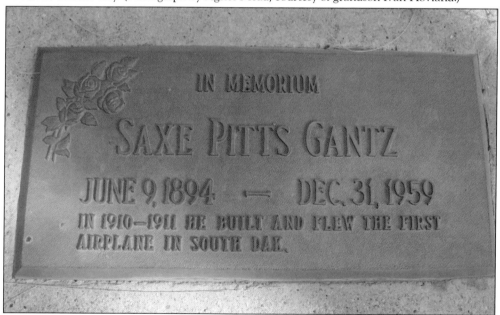

Saxe Pitts Gantz was the first South Dakotan to fly. He witnessed the Rapid City flights in March 1911, and went to Kinloch Park, Missouri, for lessons. He built a Curtiss-style airplane and flew that summer. His family meant well, but dates are wrong on his Silver City grave marker. He was born in 1884, not 1894. He flew his plane in 1911, not 1910. (Photograph by Norma Kraemer.)

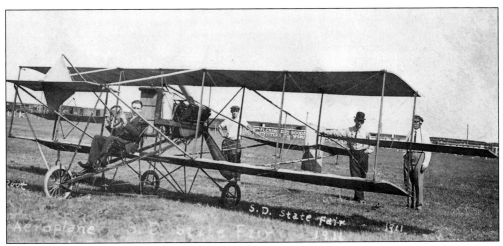

The Rapid City flights were such a success that the South Dakota State Fair in Huron hired three pilots. The fair was held in mid-September, with huge crowds wanting to see the flyers. Besides Hugh Robinson, who had flown in Rapid City, there were Cromwell Dixon and Jimmie Ward. Pilots received salaries of $20 per week and $50 per flight. (Courtesy of Cecil Ice.)

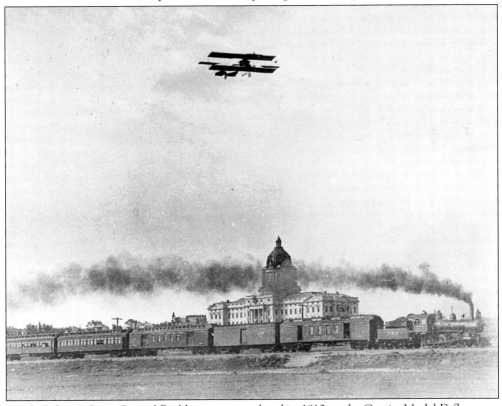

South Dakota's State Capitol Building was completed in 1910, and a Curtiss Model D flew over a few years later. The plane arrived in Pierre by train. Until 1919, airplanes were transported only by train in the state. In that year, Capt. W. W. Spain, the first South Dakota military pilot, flew between Aberdeen and Redfield during a Victory Loan Aerial Circus. (Courtesy of South Dakota State Archives.)

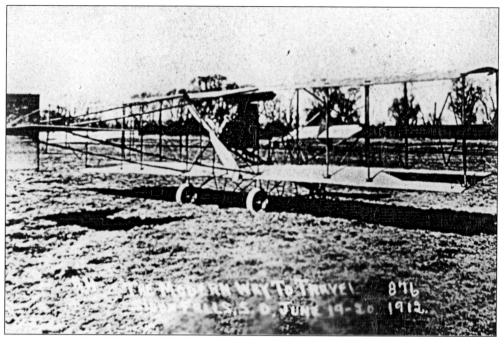

The first plane to fly at Sioux Falls did so between June 18 and 20, 1912. The Curtiss Model D used Coats Athletic Field, located at East 26th Street beyond the river. (Courtesy of South Dakota State Archives.)

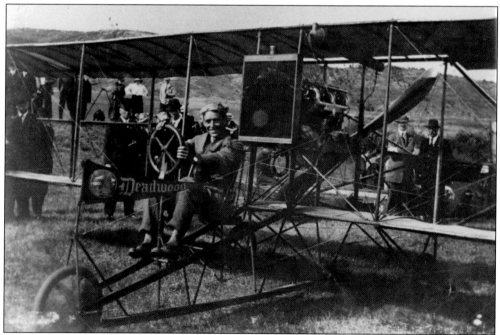

Deadwood's Business Club used the flight of Art Smith on August 3, 1912, as a fundraiser to build Deadwood Auditorium. Smith was the third pilot to be hired, but the first to fly. No pilot would take off from the rodeo grounds because of terrain. Smith's Curtiss airplane took off from a hayfield near Roo Ranch and landed at the rodeo grounds ballpark. (Courtesy of Adams Museum.)

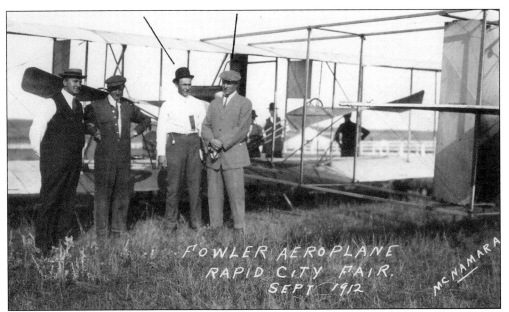

In 1912, the Rapid City fair hired Robert G. Fowler to demonstrate his Wright Model B aeroplane. (Courtesy of MHAJM)

The South Dakota State Fair was so happy with the 1911 flights at Huron that it hired pilots from the National Aeroplane Company to fly for the 1912 fair, drawing the largest crowds in its history. There were two biplanes and a monoplane. Two of the fliers were from abroad: Marcel Tournier, a Frenchman, and Paul Studenski, a Russian. (Courtesy of South Dakota State Archives.)

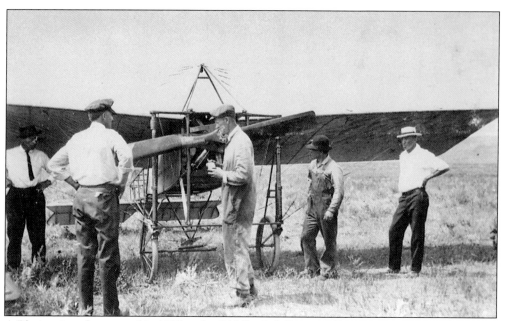

A Bleriot aircraft appeared in 1915 at the Old Settler's Picnic at Fort Pierre. Most South Dakota flights were visiting planes. (Courtesy of South Dakota State Archives.)

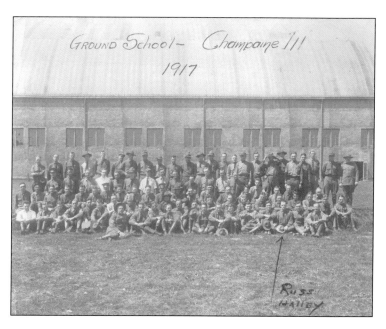

Ground School – Champaine Ill
1917

Russ Halley

With the advent of World War I, South Dakotans flew with the Escadrille Américaine or the Royal Air Force. This photograph shows Russell Halley and his ground school class at Champaign, Illinois, in 1917. Halley earned the Croix de Guerre from France. Other South Dakotans who flew in the war were Walter Smith, W. W. Spain, Douglas Stillwell, and Walter Halley. (Courtesy of MHAJM.)

Two

FROM BARNSTORMING
TO BUSINESSES

After the Great War, South Dakota joined the nationwide craze for watching barnstormers. Surplus military planes from World War I made buying a plane comparatively easy for pilots. South Dakota's wide open prairies were ideal landing spots for these gypsy pilots. But a few of these gypsies decided they wanted a stable aviation industry that provided reliable service to the far-flung population. Cross-country travel in the state relied on trains. Roads were poor and even today, seem to hug section lines rather than provide direct routes.

The two most heralded pilots of this early era are Harold Tennant and Clyde Ice. Both started as barnstormers but evolved into aviation powerhouses. Tennant's career was cut short by a crash while test flying a Kari-Keen. However, Ice lived to the age of 103 with the distinction of crop dusting into his 80s. On his 100th birthday in 1989, he flew a J-3 Cub that he had used during World War II for instruction in the Civilian Pilot Training Program he operated at Spearfish.

The truly pivotal event that inspired South Dakota to embrace the airplane was Charles Lindbergh's 1927 air tour, during which he landed at Sioux Falls, Stevens (now a part of North Sioux City), and Pierre. Aviation in the state really "took off" after that event.

By the late 1920s, astute thinkers realized that without quality airports, planes would have limited usefulness. Early on, most local governments had no interest in providing safe places to land. Private operators tried to meet the needs of the flying public. Without the U.S. Postal Service setting requirements for airport facilities, local governments would not have been forced to provide airports.

Airmail led to reliable airline service. Early airlines in the state were charter services. Today people think nothing of getting on a scheduled air carrier and being halfway around the world in less than a day. Sioux Falls, Rapid City, Aberdeen, Pierre, and Watertown have airline service as South Dakota marks its 100th anniversary of flight.

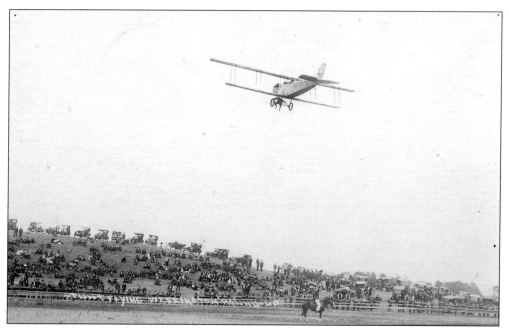

After World War I, barnstormers toured South Dakota with surplus Curtiss JN-4 "Jenny" airplanes, often featuring wingwalkers like this one at the Wessington Rodeo in 1918. (Courtesy of South Dakota State Archives.)

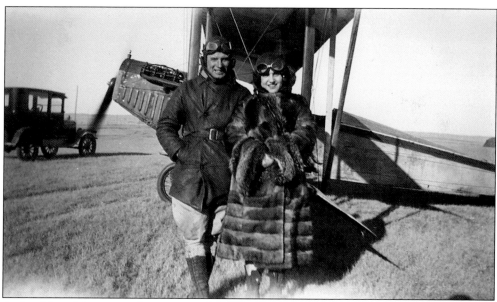

Audra Adams Hegna must have treasured this picture of herself and a pilot with his Jenny aircraft. However, she did not write down the pilot's name in her scrapbook. Barnstormers toured the state, landing in stubble fields and giving people their first rides in the 1920s. The wide open prairies offered plenty of places to land without having to go to an airport. (Courtesy of South Dakota State Archives.)

The first airport in Rapid City was constructed in 1924 by Carl Leedy, a reserve army officer, using a city street grader. It was next to the railroad tracks by East North Street. The field was too short for the U.S. Army Air Corps aircraft when President Coolidge made the Black Hills his summer vacation location in 1927. Army planes landed at Hot Springs to carry mail for the president. (Courtesy of MHAJM.)

Harold Tennant started flying in 1921 in Sioux Falls with a Curtiss JN-4-D, opening his office in the O. P. Moore Grocery Company building. Over the next several years, he did stunts and charter flights with his fleet of aircraft. He operated a Boeing flying boat on Lake Madison starting in 1923. By 1927, he operated a flying school at Renner Airport. (Courtesy of Norma Kraemer.)

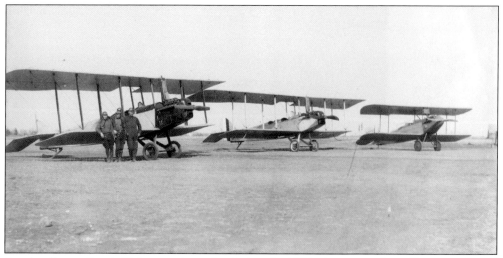

People all over South Dakota embraced aviation. In 1926, three men from Platte purchased planes. From left to right are Ray Fuller, Herb Hansen, and Wilbur (Babe) Cool with a Standard that cost $800 new, a Standard that cost $600 used, and a Waco 10 that cost $3,000 new. Herb Hansen also worked with Harold Tennant of Sioux Falls barnstorming around the state. (Courtesy of Clarence Hansen.)

South Dakota's best-known pilot, Clyde Ice, was from Miller. He taught himself to fly in 1921. On his first flight, he took two paying customers to a ball game in Aberdeen. Ice had been working as a ticket seller for barnstormer K. O. Schneider and thought Schneider would teach him to fly, but Schneider instead simply told him to fly the passengers. (Courtesy of Marion Havelaar.)

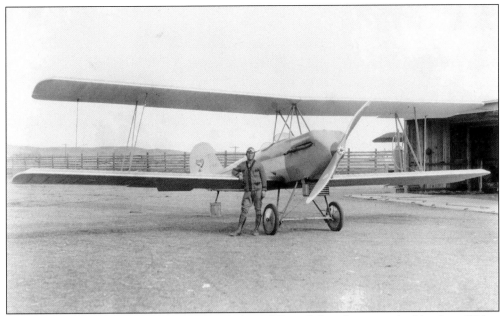

Clyde Ice moved to Rapid City in 1927. Clyde and Bert Gilbaugh approached bankers Walter and Russell Halley to form Rapid Air Lines. They were allowed to use the city's airport at no charge. Ice worked with Rise Studios of Rapid City to take aerial photographs around the state that became commercially successful. Ice brought four airplanes to the company from Miller. (Courtesy of Howard Ice.)

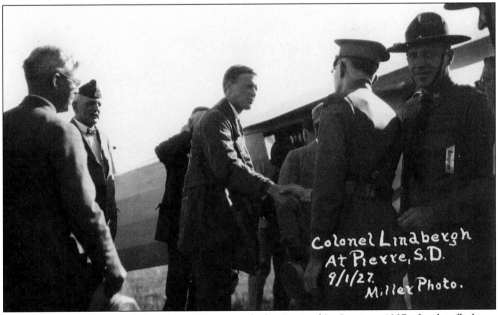

Charles Lindbergh toured the United States with the *Spirit of St. Louis* in 1927 after his flight to Paris. In South Dakota, he landed at Sioux Falls, Rickenbacker Field at Stevens (North Sioux City), and Pierre. He dropped messages over Aberdeen and Huron. On his way from Pierre to Wyoming, Lindbergh dropped a message at the State Game Lodge for Pres. Calvin Coolidge. (Courtesy of South Dakota State Archives.)

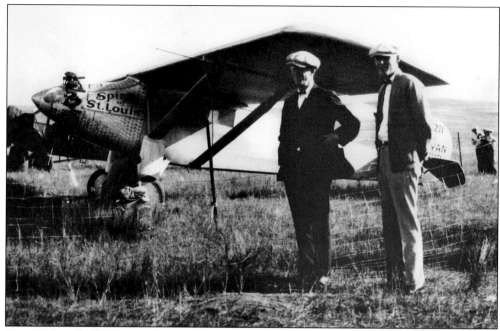

Two unidentified men stand next to Lindbergh's *Spirit of St. Louis* while it was in Pierre on September 1, 1927. Lindbergh spent the night in Pierre. When Sioux Falls learned that it would host Lindbergh, the Renner Airport was established 5 miles north of town. Sioux Falls attracted 50,000 people at Renner when he landed. (Courtesy of South Dakota State Archives.)

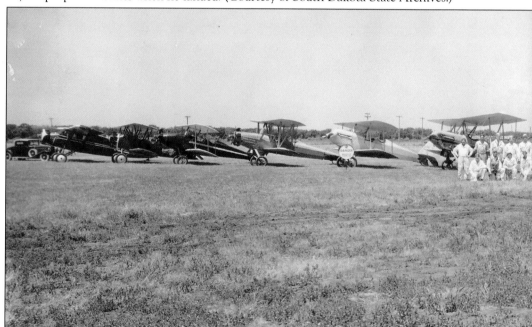

Sioux Falls was enjoying airshows at Renner Airport by 1929. Airplanes shown here, from left to right, are the Stinson SM-2 Junior, Travelaire, unidentified, Eaglerock with a Kinner engine, and four Alexander Eaglerocks with OX-5 engines. The only pilot who can be identified easily in this picture is Nellie Zabel Willhite, since she is the only woman in the group. Her plane *Pard* is on the far right.

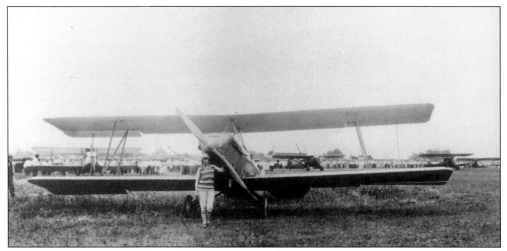

Harold Tennant formed Dakota Airlines flight school in November 1927. He convinced a woman observer at Renner Airport that if she learned to fly, she would be the first female pilot in the state. That woman, Nellie Zabel Willhite, soloed on January 13, 1928, and eventually earned a transport license. She purchased an Alexander Eaglerock from Clyde Ice and worked as a pilot until the 1950s. (Courtesy of Marilyn Madison.)

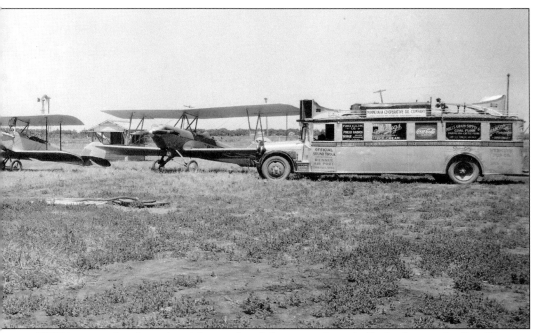

Willhite gave the plane the nickname her father earned as a bull whacker on the Fort Pierre to Deadwood trail. She flew him over the course of the trail and on to Sheboygan, Wisconsin, in this plane in 1928. Renner served as Sioux Falls's area airport until a Works Progress Administration grant helped the city build the airport at its current location. (Courtesy of CFWSAC.)

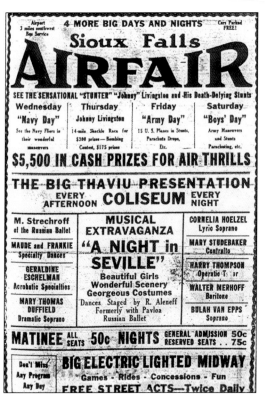

By 1928, Dakota Airlines at Sioux Falls decided Renner was too far from town and took an option on a city field near 41st Street and the pipeline terminal. The 1929 Sioux Falls Airfair was held at this new location. This airport was called Sioux Skyways. By 1937, it was obsolete, because it could not handle multi-engine airplanes safely. (Courtesy of Jim Anez.)

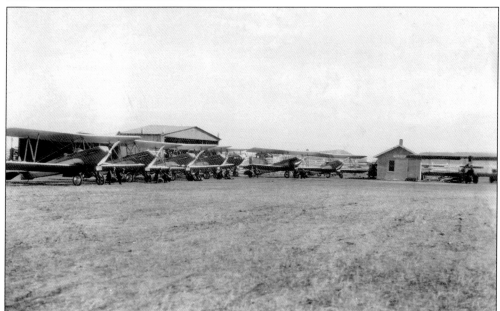

Rapid Air Lines became a dealer for Alexander Eaglerock airplanes built in Colorado Springs, Colorado. In 1927, the Rapid Air Lines sold 12 airplanes, owned three, and made a profit of 100 percent. It also built a hangar and office building. By 1928, the company employed 12 pilots and 11 mechanics, flew 7,369 flights for 2,140 hours, and carried 65,000 passengers. (Courtesy of Howard Ice.)

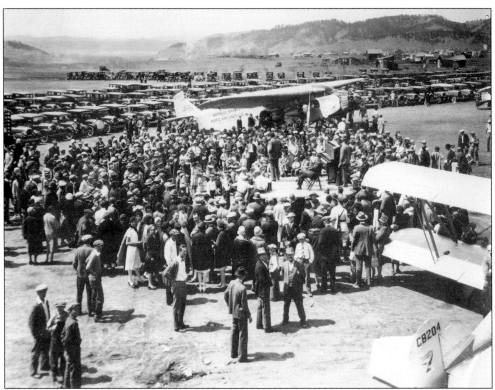

Rapid Air Lines, Inc., bought the first Ford Trimotor in the state in May 1928, for the price of $45,000. Pilot Clyde Ice barnstormed with it in the east, clearing $13,500 in his first 10 days of flying. His partners, the Halleys, insisted Clyde bring the plane back to Rapid City. The city turned out on July 2, 1928, for a huge celebration. (Courtesy of LDCLWHS)

Passengers on the Rapid Air Lines Ford Trimotor, *Wamblee Ohanko* ("Swift Eagle" in the Sioux language), all received souvenir tickets featuring a picture of the plane and its pilot, Clyde Ice. The company called itself an airline but never successfully provided the scheduled service people associate with an airline today. All attempts at scheduled service failed after a few months. (Courtesy of Luverne Kraemer.)

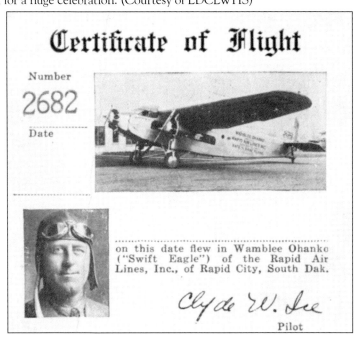

Certificate of Flight

Number

2682

Date

on this date flew in Wamblee Ohanko ("Swift Eagle") of the Rapid Air Lines, Inc., of Rapid City, South Dak.

Clyde W. Ice

Pilot

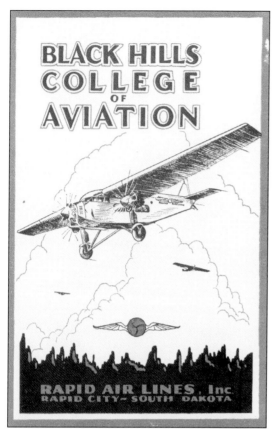

Airport operators around the state aggressively sought students. This booklet for the Black Hills College of Aviation went to great lengths to encourage people to learn to fly within a structured curriculum. The college claimed to operate two airports in Rapid City. The basic course cost $485, while a limited commercial license was $970, and a transport license was $2,185. (Courtesy of Luverne Kraemer.)

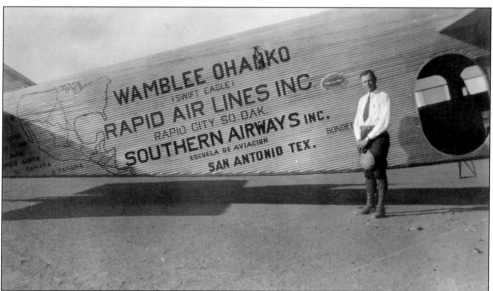

In 1929, Rapid Air Lines, Inc., tried to establish an airmail route from Rapid City south through Texas to Panama. Jim Welling is standing next to the Rapid Airlines Ford Trimotor and was part of Clyde Ice's crew. The company was unsuccessful in getting a contract with the government. This picture was taken at Mexico City on January 8, 1929. (Courtesy of Robert Erlandson.)

GET THE MOST FROM
YOUR ENGINE WITH A

Fahlin
PROPELLER

Give your engine a "break"—use all
those "horses"—and enjoy the added
pleasure and pride that comes from
having a truly fine propeller. Use a
Fahlin propeller for superior perform-
ance, strength, and dependability.

Championship Performance

The first and only time a racing plane equipped
with a wood propeller has won the Thompson
Trophy (1937 National Air Races) a Fahlin
propeller was used. Fahlin propellers have been
proving themselves of championship caliber
for 20 years—a number of them are known to
have given efficient service after more than
10 years of constant use.

Why FAHLIN PROPELLERS
DELIVER SUPERIOR PERFORMANCE

1. **SPECIAL AIRFOIL DESIGN** (an exclusive Fahlin feature)
 increases efficiency, helps to eliminate flutter, and adds
 years to the propeller's service. A major factor con-
 tributing to Fahlin's famous "superior performance."

2. **FINEST MATERIALS.** Each propeller is made of selected birch
 lumber—thoroughly seasoned and tested to exact moisture
 content.

3. **FINEST FINISH.** Special, high quality clear varnish fur-
 nishes extra over-all protection from the elements.

4. **PERFECTLY BALANCED** and calibrated.

5. **DOUBLE THICKNESS TIPPING** provides greater strength on
 tips and leading edge. Another plus feature of Fahlin
 propellers.

FREE folder sent on request—gives full details of Fahlin
features. Write TODAY for your copy.

Fahlin
Manufacturing Co.
COLUMBIA, MISSOURI

West Coast Distributor
AIR-PARTS, INC. — GLENDALE, CALIF.

APRIL, 1944

Ole Fahlin started his wood propeller building in Aberdeen in 1926. His propellers were noted for being matched to the engine used. They performed better than other propellers available. By 1928, he moved to Sioux City, but with the demise of the Kari-Keen aircraft company, he moved his business to Missouri. After World War II, he worked in California until his death. (Courtesy of Luverne Kraemer.)

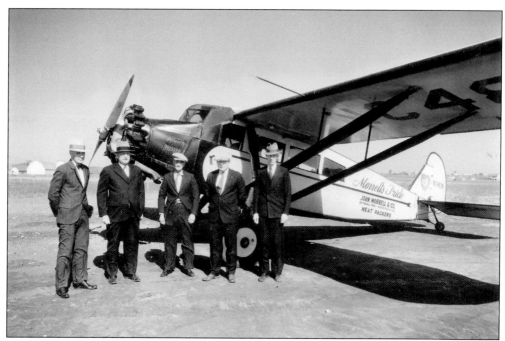

By 1931, John Morrell and Company used a Ryan Brougham to reach its customers, retail meat dealers. Flight time was 1 hour 45 minutes, Pierre to Sioux Falls, and 2 hours to return. J. C. Cook's territory included, from left to right, H. B. Johnson, Murdo; Anton Fischer, Fort Pierre; Gus Howard, Blunt; Arthur Nelson, Murdo; and Dan Carver, pilot. (Courtesy of Larry Nelson.)

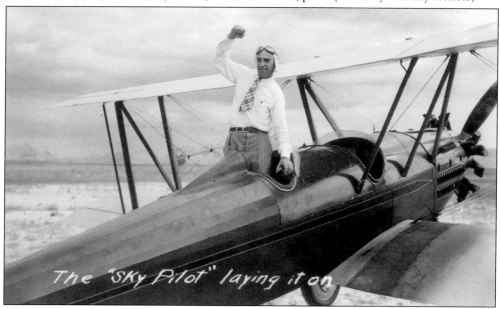

Clergy also saw the potential in saving souls via airplane. Carl H. Loocks, the "Black Hills Sky Pilot," traveled western South Dakota with Russell Halley as his real pilot. This shows Loocks preaching in the badlands near Scenic-Conata to some 200 people in August 1934. Loocks also had some fanciful notions for designing an airship called an Aerozep, but they never materialized. (Courtesy of MHAJM.)

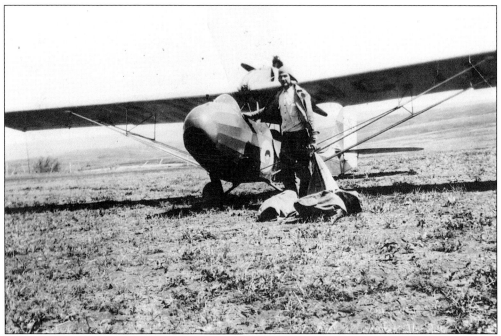

John Norman of Lacy used a Curtiss Junior to deliver mail in the 1930s. (Courtesy of South Dakota State Archives.)

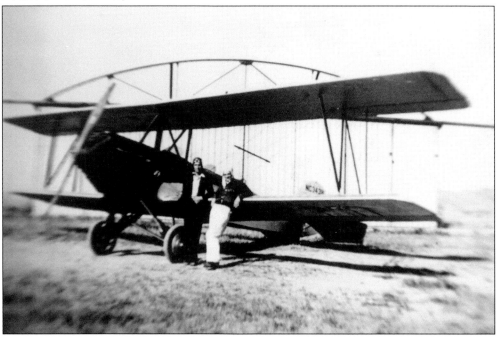

In 1935, Ralph Burton (left) took Ivan Ellis up for his first flight in his Alexander Eaglerock at Halley Airport. Halley traffic was down 80 percent after Black Hills Airport opened. Halley Airport was still Rapid City's primary airport, because the city could not decide on a location for a municipal airport. Russell Halley offered to sell the city the airport; they declined the offer. (Courtesy of Robert Burton.)

Entrepreneurs around the state used airplanes for all sorts of business purposes. This plane was used in Madison to deliver fresh bread to outlying communities. (Courtesy of South Dakota State Archives.)

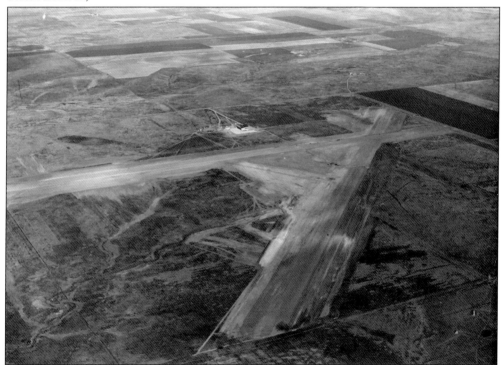

The Depression fostered airport construction around South Dakota via funding from Works Progress Administration grants. Rapid City completed its airport in 1938, three years after Spearfish. The United States Postal Service would not use privately owned airports, so Halley Airport was not considered for mail service. Halley even offered to sell his airport to the city, but terrain concerns led postal officials to refuse air mail service to Halley. (Courtesy of MHAJM.)

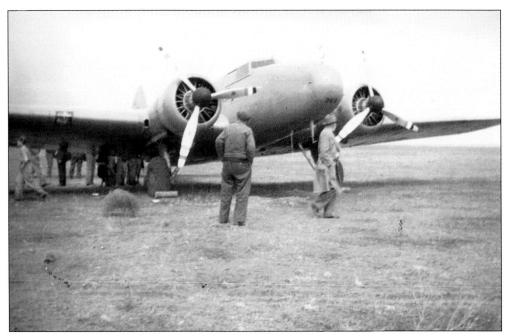

In 1938, Pierre received airmail service on the Huron/Pierre/Rapid City/Spearfish/Cheyenne route provided by Western Air Express. Besides mail service across South Dakota, the route brought scheduled passenger service in this Boeing 247D. Air service across the state improved dramatically in 1937 with 15 airports across the state suitable as transport landing fields. (Courtesy of South Dakota State Archives.)

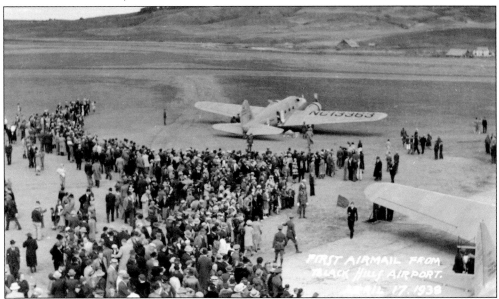

Western Air Express landed at Spearfish's Black Hills Airport to pick up mail and passengers in 1938. The first airmail plane at Spearfish picked up 80 pounds of airmail, while the plane only picked up 45 pounds at Rapid City. Spearfish intermittently had airline service from 1938 until the 1990s. By the end of World War II, Rapid City's population and airport activity surpassed that of Spearfish. (Courtesy of LDCLWHS.)

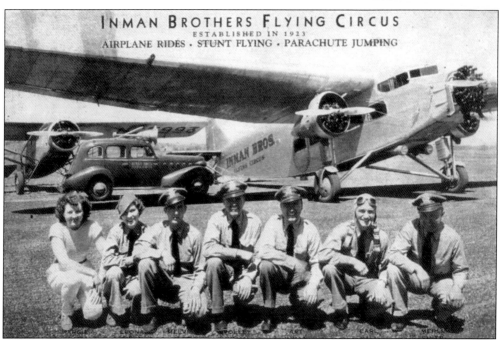

INMAN BROTHERS FLYING CIRCUS
ESTABLISHED IN 1923
AIRPLANE RIDES · STUNT FLYING · PARACHUTE JUMPING

Flying circuses made their way through South Dakota through the 1930s. This 1937 Inman Brothers Flying Circus postcard was sent to post office boxholders in small towns like Scotland and Hudson to let them know the planes would be there to give people rides. The reverse side of the postcard (below) let the residents know when to expect them and what type of plane they would see. The Inman Brothers started flying in Mason City, Iowa, but toured a large area. The advertised Boeing never showed up at this appearance. They brought a Ford Trimotor and a Travelaire. (Courtesy of Marion Havelaar.)

Dear Friend:—
The Inman Bros., Flying Circus is bringing its giant airline to Scotland, Friday morning, Aug. 13, and will remain until 3:00 p. m. You are cordially invited to attend and inspect the 10-ton Boeing Clipper, America's largest tri-motor. The ship will be available for passenger rides at 50c for the first hour after landing, and $1.00 for the long-high ride thereafter.
Respectfully yours,
Art Inman and Henry Johnson.
Using Standard Aviation gasoline furnished by Henry Johnson

BOXHOLDER

LOCAL

The Inman Brothers Flying Circus landed 3 miles west of Scotland. Marion Havelaar got his first airplane ride for 50¢ in their Ford Trimotor at age 14. His mother is in the white dress under the wing about halfway down from the wingtip. The day was very hot, so everyone tried to find shade under the wing of the plane. (Courtesy of Marion Havelaar.)

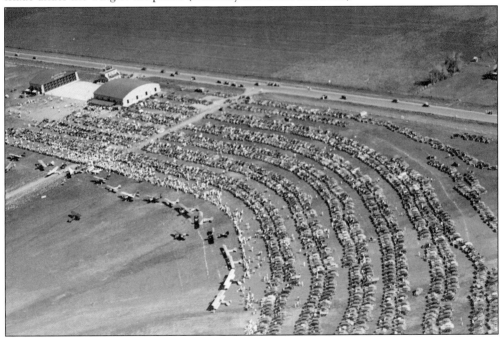

The public was eager to see aviation events, as shown by this aerial picture of the sixth annual Black Hills Air Fair in July 1939 at the Spearfish Airport. Advertisements proclaimed it the Northwest's biggest air show. Clem Whittenbeck, Art Davis, and the Colorado National Guard filled the bill, along with airplane races, aerial contests, and flying through a wall of fire. (Courtesy of South Dakota State Archives.)

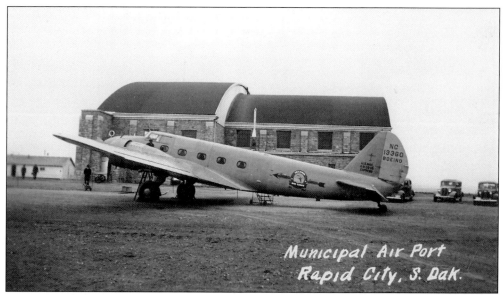

Inland Airlines served South Dakota for some years with a Boeing 247D. This picture shows it next to the hangar at Rapid City Municipal Airport in 1940. (Courtesy of Luverne Kraemer.)

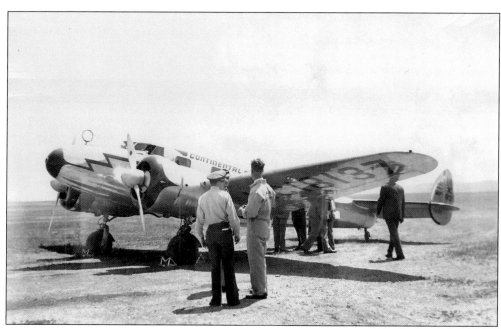

Rapid City Municipal Airport had traffic from Continental Airlines by 1940 when this picture was taken. Continental flew a Lockheed Electra 12A. (Courtesy of Luverne Kraemer.)

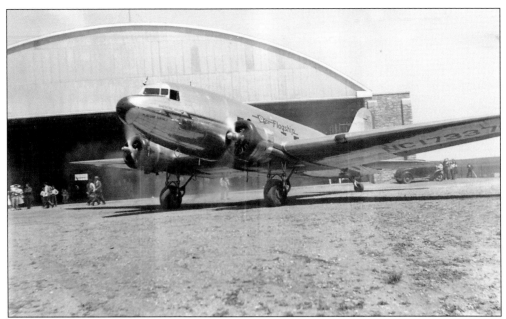

American Airlines used a Douglas DC-3 to serve Rapid City Municipal Airport in 1940. (Courtesy of Luverne Kraemer.)

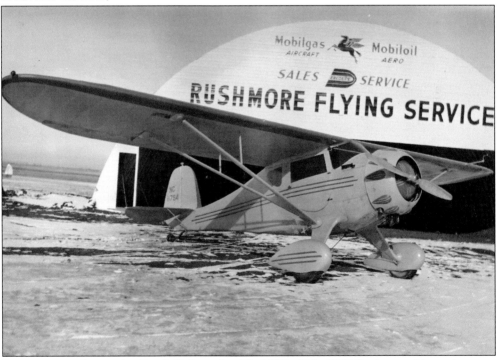

Private airports boomed in South Dakota after World War II. In 1946, Rushmore Airport between Rapid City and Ellsworth Air Force Base was built. Ralph Letler, Ivan Ellis, and John George operated Rushmore Air Service until construction of U.S. Interstate 90 closed it. The company operated this Monocoupe 90A and had an Ercoupe dealership. Ivan and John left in 1948 over disagreements with Ralph. (Courtesy of Robert Burton.)

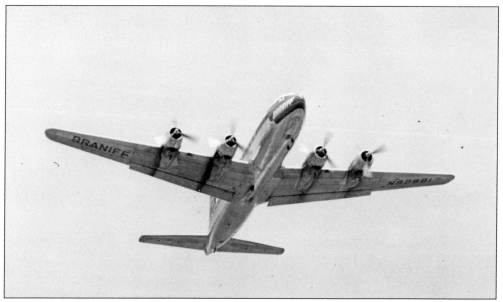

Braniff Airlines served eastern South Dakota towns with DC-4 aircraft in the 1950s. Braniff merged with Mid-Continent Airlines in 1952. Mid-Continent served eastern South Dakota starting in 1938 when it acquired a controlling interest in Hanford Airlines. Hanford Tri-State Airlines had been started in 1928 at North Sioux City. They owned Rickenbacker Field, today called Graham. (Courtesy of Luverne Kraemer.)

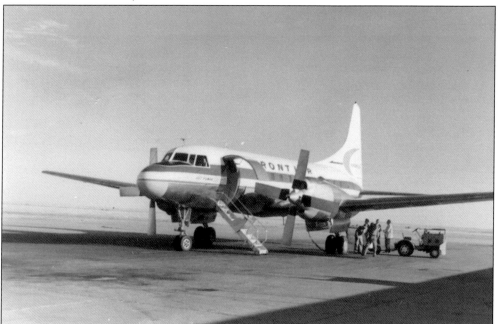

The maiden flight of Frontier Airlines used a DC-3 into Rapid City on April 1, 1959. The route to Denver had intermediate stops at Hot Springs, Chadron, Alliance, Scottsbluff, and Cheyenne. From 1959 to 1964, Frontier used a Convair 340. In 1964, the company started using the plane pictured, a Convair 580. In 1966, a Boeing 727 provided direct service between Denver and Rapid City. (Courtesy of MHAJM.)

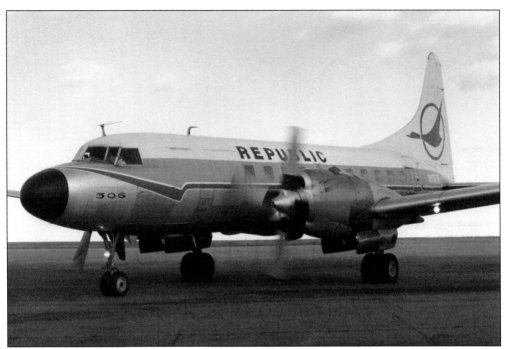

Republic Airlines served South Dakota after the merger of North Central Airlines with Southern Airways and Hughes Airwest in 1979. In 1986, Republic was purchased by Northwest Airlines. Northwest merged with Delta Airlines in October 2008 and ceased to fly under the Northwest name. (Courtesy South Dakota State Archives.)

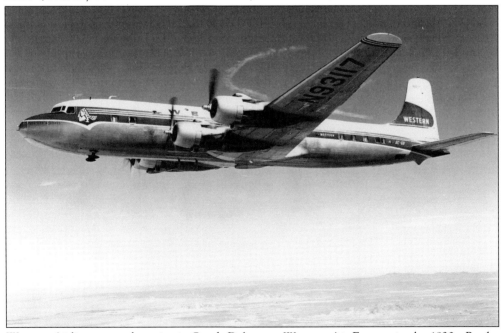

Western Airlines started service in South Dakota as Western Air Express in the 1930s. By the 1960s, they were using a DC6. In 1986, they were purchased by Delta Airlines and ceased to fly under the Western logo. (Courtesy of South Dakota State Archives.)

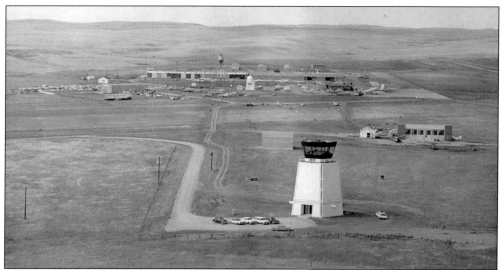

The U.S. Air Force forced Rapid City Municipal Airport to relocate from its original location so Ellsworth Air Force Base could have sole use of the city's airport. This 1964 view of the current Rapid City airport location shows the grass runway in the center of the picture that is now covered by the passenger terminal. Major airport construction in the 1980s rearranged runways and buildings. (Courtesy of Luverne Kraemer.)

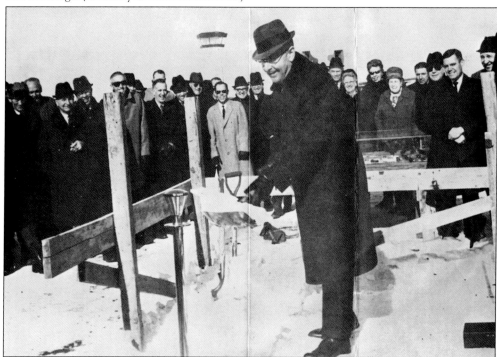

The 1968 Sioux Falls groundbreaking ceremony became a snow breaking ceremony as Mayor M. E. Schirmer lifted snow instead of frozen ground at the site of the new Sioux Falls terminal building. Construction marked another milestone of aviation progress in Sioux Falls and in South Dakota. The airport was named Joe Foss Field in 1955 in honor of the World War II ace. (Courtesy of Luverne Kraemer.)

Three

SOUTH DAKOTA
LOOKS TO SPACE

A unique blessing of geology led South Dakota to be chosen for a joint U.S. Army and National Geographic Society balloon launch in 1934 that can be credited as a starting point in the U.S. space program. Capt. Albert Stevens was a balloonist and aerial photographer at army research facilities in Dayton, Ohio, when he conceived of the idea to take a balloon into the stratosphere. He was able to get support for the project from the army and the National Geographic Society. He and his project officers, Maj. William Kepner and Capt. Orvil Anderson, found the unique features of what is called the Stratobowl, near Rapid City, ideal for their launches. This protected area allowed for inflation of the huge balloons without worrying about sudden winds.

The first flight, Explorer I, ended in Holdrege, Nebraska, after the balloon exploded and the gondola plummeted to the ground. The three men escaped by parachute. The second flight, Explorer II, was a huge success. Explorer II landed safely at White Lake after reaching an altitude that held a world record until the 1950s of 72,395 feet. Captain Stevens was able to get the first picture of the curvature of the earth on this flight.

The Stratobowl has been used by a variety of others for research flights and balloon record attempts. Steve Fossett attempted his first round-the-world solo balloon flight from the Stratobowl, but only reached New Brunswick, Canada.

Balloon flights of the 1930s inspired Ed Yost's fascination with balloons. With others, he established Raven Industries in Sioux Falls in the 1950s. The company went on to develop a whole new way to explore the skies, not only with sport hot air balloons but also with a variety of research balloons.

The state can also lay claim to one modern-day astronaut, Charles Gemar. He served as a space shuttle mission specialist. Today the South Dakota Space Grant Consortium sponsors programs to encourage young people to consider aviation careers. These could be the leaders of South Dakota's second century of aviation.

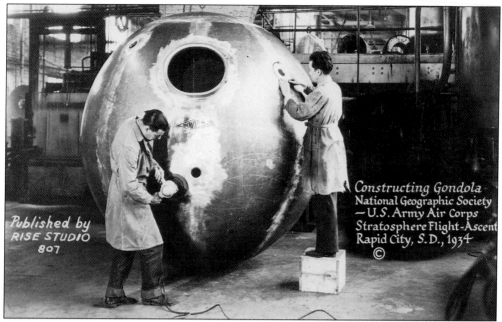

The gondola of Explorer I was constructed in Rapid City and was designed to carry three aeronauts aloft. It carried equipment for 63 research studies plus a crew of three. It weighed more than 3,000 pounds. (Courtesy of South Dakota State Archives.)

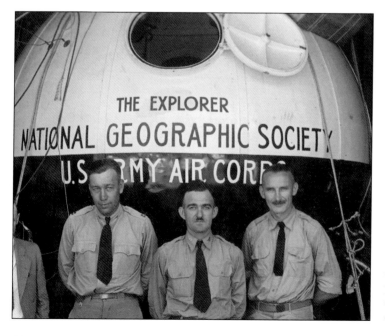

The Stratobowl crew was, from left to right, Capt. Orvil Anderson, Maj. William Kepner, and Capt. Albert Stevens. The flight had been conceived by Stevens, a noted aerial photographer, to float a scientific laboratory above 70,000 feet for research and observation. Major Kepner was a balloon pilot for the army. Captain Anderson was the operations officer for the project and served as co-pilot. (Courtesy of MHAJM.)

Research on the stratosphere was done by a cooperative effort of the U.S. Army Air Corps and the National Geographic Society in 1934 with the launch of Explorer I. They chose a site to launch their balloon 12 miles southwest of Rapid City at a natural bowl today called the Stratobowl. Inflation is shown in this picture taken at 3:00 a.m. on July 10, 1934. (Courtesy of South Dakota State Archives.)

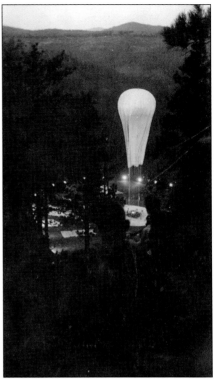

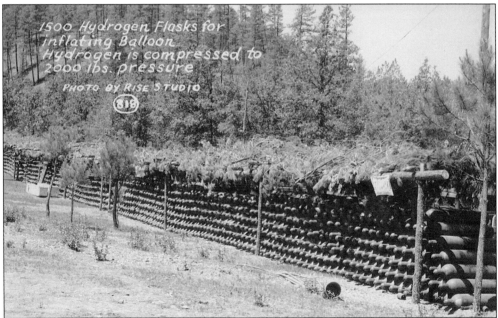

It took six hours to inflate Explorer I with 1,500 hydrogen cylinders, each storing 190 cubic feet. The tanks were kept covered with pine boughs to keep the cylinders from getting too hot. The Stratocamp had its own fire department because of the potential for fire. In flight, Explorer I exploded over Nebraska. The crew was barely able to escape by parachute. (Courtesy of South Dakota State Archives.)

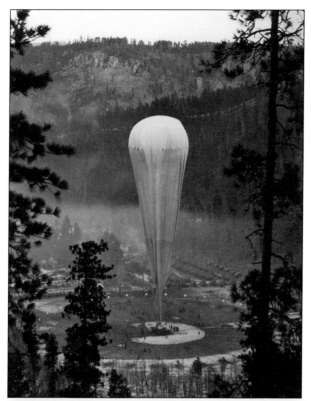

Explorer I was launched on July 28, 1934, and reached an altitude of 60,613 feet. Once clear of the Stratobowl, the balloon drifted towards Holdrege, Nebraska, crashing 10 hours later. As it ascended, the balloon became round from expansion of the gas contents and ripped open. The crew parachuted some of the scientific instruments to safety before using their own parachutes to escape. (Courtesy of South Dakota State Archives.)

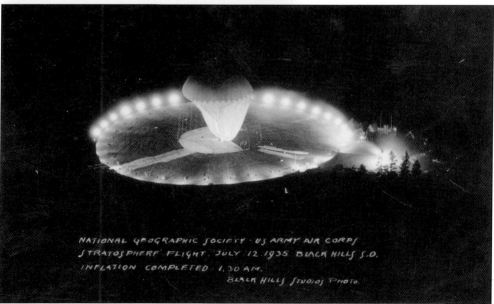

NATIONAL GEOGRAPHIC SOCIETY - US ARMY AIR CORPS
STRATOSPHERE FLIGHT. JULY 12.1935 BLACK HILLS S.D.
INFLATION COMPLETED 1.30 A.M.
BLACK HILLS STUDIOS PHOTO.

The U.S. Army and National Geographic Society attempted a second flight at the Stratobowl in July 1935. This time, the crew inflated the balloon with helium, a nonflammable gas. Since helium has approximately half the lifting ability of hydrogen, only two people could ascend. After inflation, Explorer II developed a tear and collapsed. It was sent back to the Goodyear-Zeppelin Company for repairs completed by November. (Courtesy of LDCLWHS.)

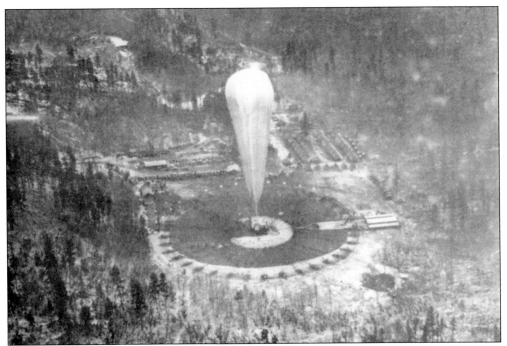

The second attempt to launch Explorer II started on November 10, 1935. During inflation, a 17-foot tear developed just below the equator of the bag. It was repaired with a roll of fabric and rubber cement, and two 500-watt light bulbs were used to set the glue in the winter conditions. After launch on November 11, the balloon reached a record altitude of 72,395 feet. (Courtesy of Luverne Kraemer.)

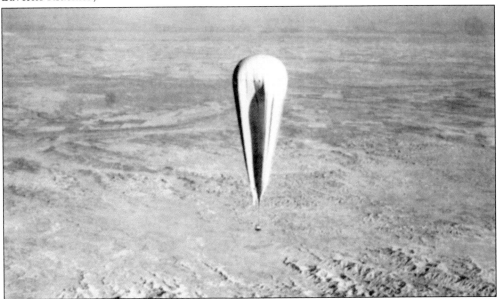

Explorer II drifted across South Dakota as seen in this picture of the Badlands. The crew stopped the ascent at 16,000 feet for a final outside inspection. Then the gondola was sealed and the oxygen system started. It was fully inflated at 65,000 feet. The crew continued to discharge ballast until the balloon reached an indicated altitude of 73,000 feet. (Courtesy of Luverne Kraemer.)

Explorer II landed near White Lake before sunset. The controlled landing brought an end to 63 studies conducted. Local residents raced to see the balloon land, but the army had a unit from Fort Meade race to the site to protect the gondola from souvenir hunters. The gondola is now in the Smithsonian's Air and Space Museum in Washington, D.C. (Courtesy South Dakota State Archives.)

After World War II, stratosphere research continued at the Stratobowl. The navy had a project called Stratolab that used both closed gondolas and open baskets. The fourth Stratolab flight took place on November 28 and 29, 1959. Comdr. Malcolm Ross and Charles Moore reached 81,000 feet. For this flight, the capsule carried a 16-inch telescope, so Moore could observe Venus. (Courtesy of South Dakota State Archives.)

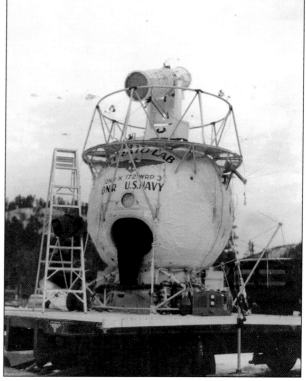

The navy constructed a building to house the gondola of Stratolab IV. That building is at the same site today. The land is privately owned and access to see the Stratobowl is limited to foot traffic from U.S. Highway 16, since the forest service has closed the gate for the road to the rim. (Courtesy of South Dakota State Archives.)

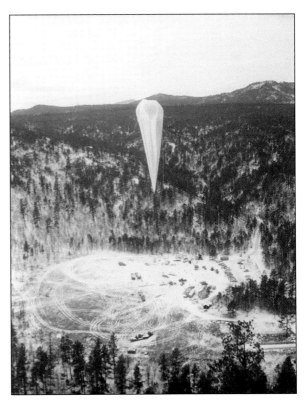

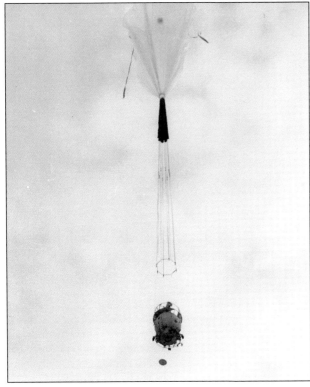

Stratolab IV reached an altitude of 81,000 feet. The navy's program helped in the development of space suits for the astronauts. The balloons used for these flights were no longer rubber-coated fabric, but a thin layer of polyethylene plastic that was not affected by the conditions at high altitude. Scientific research included astronomy, physics, and human physiology. (Courtesy of South Dakota State Archives.)

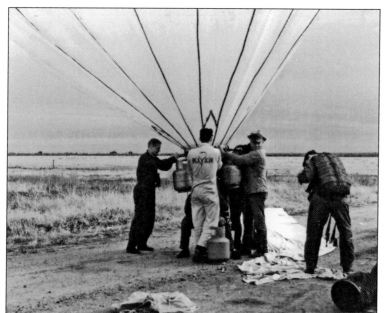

A spin-off of the navy's balloon research of the 1950s was Ed Yost's invention of the modern hot air balloon in Sioux Falls. Ed leased his airplane to General Mills's research for the navy. He formed Raven Industries in 1956 with J. R. Smith, Duwayne Thon, and Joseph Kaliszewki. Yost designed a method of heating the air in the balloon with propane. (Courtesy of Rekwin Archives.)

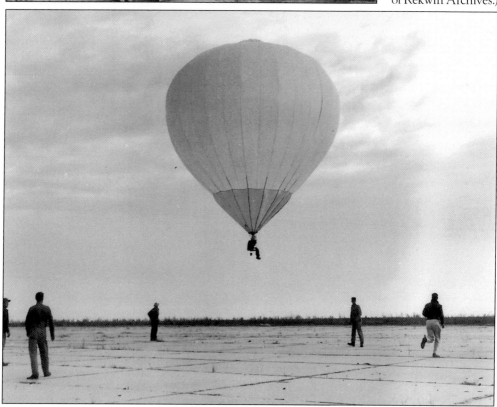

Looking for favorable weather, the first flight of Ed Yost's balloon was at Bruning, Nebraska, at an old military runway on October 22, 1960. He was the test pilot. The use of heat resistant, nonporous fabrics, a relatively light propane burner, and the teardrop design of the envelope became standard features in hot air balloon design. (Courtesy of Rekwin Archives.)

In 1961, Raven Industries tried inflating the balloon with a remote heat source, but the air cooled down too much for efficient inflation. Atmospheric air needed to be forced into the balloon envelope before heating. Today large gasoline-powered fans do the inflation of the envelope before applying heat. This prototype got too expensive. The next designs were simpler. (Courtesy of Rekwin Archives.)

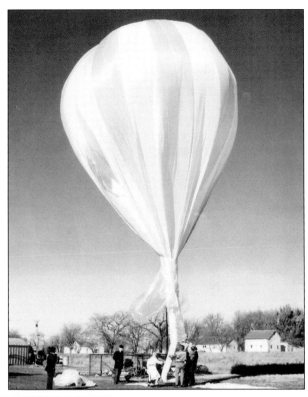

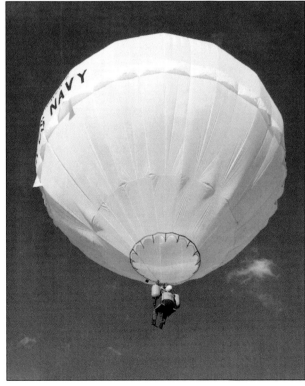

A 1961 contract from the Office of Naval Research allowed further developments in balloon inflation. On this balloon, propane tanks were made out of oxygen bottles from a B-29 bomber. Pilot Dick Keuser conducted these flights in Sioux Falls in the summer of 1961. That same year Raven sold its first "sport balloon."(Courtesy of Rekwin Archives.)

Ed Yost, left, test flies the prototype for the trans-channel balloon that he flew across the English Channel with Don Piccard in 1963. This test flight was conducted in Sioux Falls in 1962. (Courtesy of Rekwin Archives.)

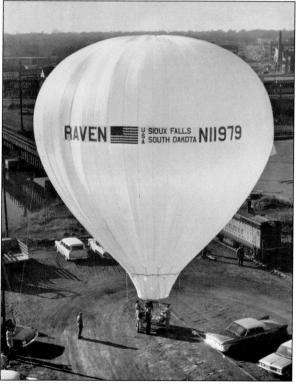

Raven's two-person balloon was designed for flight across the English Channel. Ed Yost, aeronaut, and Don Piccard as passenger flew this balloon across in 1963. Yost attempted to fly a balloon across the Atlantic Ocean solo in 1976 but was forced down in the ocean by unfavorable winds. However, he set 13 aviation world records for distance traveled and time aloft. (Courtesy of Rekwin Archives.)

In 1967, Raven Industries introduced a heavy lifting balloon with the Bohemia Lumber Company of Oregon. The new company was called Balloon Trans-Air, Inc. The balloon system could lift 15,000 pounds. Control was obtained with two winches. Not only did it lift the load, but there was ability to go laterally. It was designed for logging, construction, and ship-to-shore operations. (Courtesy of Rekwin Archives.)

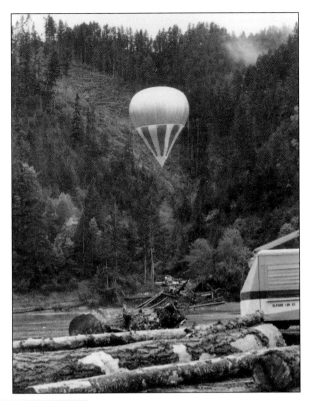

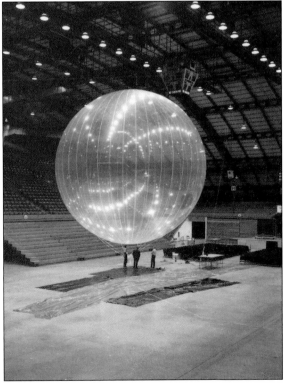

In 1969, Raven started development of super-pressurized mylar spheres with helium, used as a stationary platform for weather research. They made different sizes to meet job requirements. This balloon is inflated inside of the Sioux Falls arena for testing. This type of balloon was used in the southern hemisphere and flew around the world four times. One of these balloons stayed aloft for 441 days. (Courtesy of Rekwin Archives.)

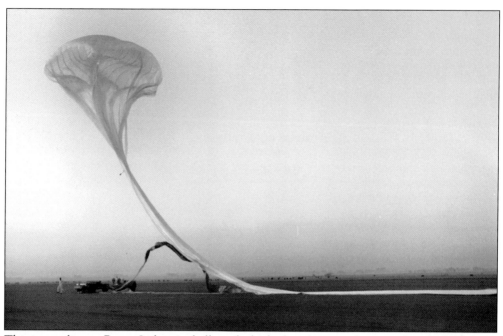

This image shows a Raven Industries balloon for high altitude scientific research in launch mode. The polyethylene balloon uses a set amount of helium. The size of the balloon and weight of the load determine altitude attained. They are constructed with volumes of 9 million to 30 million cubic feet. (Courtesy of Rekwin Archives.)

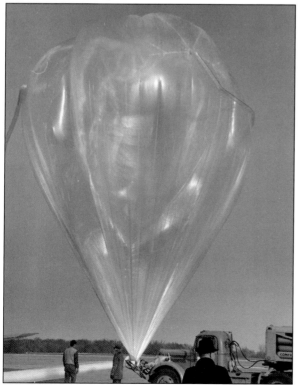

For helium balloons, Raven Industries developed a launch spool control for better inflation of the balloon. The uninflated part of the balloon is to the left of the truck. It is fed though the spool as the balloon expands. When launched, the balloon will appear to be only partially filled, because as it gains altitude, the gas will expand and make the balloon round. (Courtesy of Rekwin Archives.)

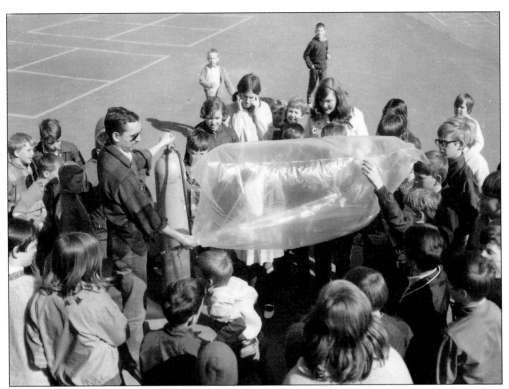

Raven's pillow balloons, made of sealed polyethylene, were used to distribute propaganda leaflets over eastern Europe during the Cold War. In this picture, school children in Sioux Falls watch a balloon demonstration. (Courtesy of Rekwin Archives.)

Raven Industries makes a large variety of tethered balloons, also called aerostats, for advertising. This balloon was done in 1975 in a fairly small size. Most today are much larger. The company makes the balloons for the Macy's Thanksgiving Day Parade. Raven Industries spun off Aerostar International in 1986 as a wholly owned subsidiary. (Courtesy of Rekwin Archives.)

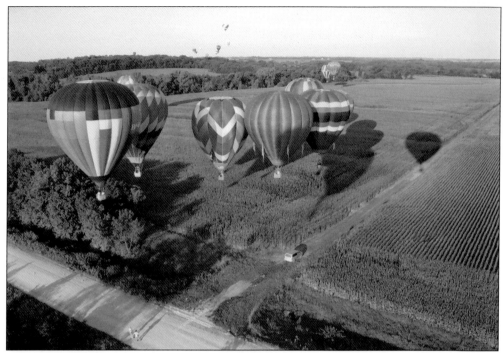

Aeronauts continue to enjoy sharing their enthusiasm for ballooning through rallies held across the country. The first Sioux Falls Balloon Race was held in 1975 at Buffalo Ridge. This is a modern balloon rally near Des Moines, Iowa, in 2009. Raven ceased manufacture of sport hot air balloons in 2007 but still supports those already manufactured. (Courtesy of Rekwin Archives.)

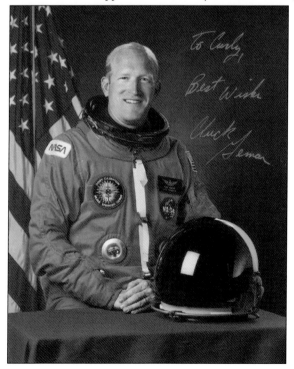

Charles Donald "Sam" Gemar, first astronaut from South Dakota, was a mission specialist for the space shuttle program. He flew three times as a crewman: November 15–20, 1990; September 12–18, 1991; and March 4–18, 1994. He was born in Yankton in 1955 but calls Scotland home where his parents live. Before becoming an astronaut, he served as a pilot in the army. (Courtesy of Marion Havelaar.)

Four

WORLD WAR II BRINGS MILITARY AVIATION TO STAY

Military aviation began in South Dakota as college students around the state took advantage of the Civilian Pilot Training Program in the late 1930s. The military presence in the state grew rapidly after the Japanese attacked Pearl Harbor in 1941. The most enduring of military aviation endeavors in South Dakota is Ellsworth Air Force Base outside of Rapid City. The state has long valued the economic benefits that this large air base provides. With agriculture and tourism, the military is one of the state's largest sources of income and its second largest employer.

The military development of airports transformed primitive grass landing strips and left behind modern, paved runways that endure, even if the military has long ceased to be active. Sioux Falls currently shares its airport with the South Dakota Air National Guard, but Rapid City was forced to build a new commercial airport after the U.S. Air Force took Rapid City Municipal for its sole use.

The South Dakota Army National Guard has based its activities and operations in Rapid City since after World War II, always at civilian facilities.

The Civil Air Patrol came into existence in the state shortly before the attack on Pearl Harbor and endures today. Members during World War II provided liaison service to the military by flying between military bases in South Dakota and Nebraska. CAP has endured as the official auxiliary of the U.S. Air Force for air search and rescue. Civil Air Patrol also serves to encourage people to fly by providing a cadet program for young people.

Before World War II started, South Dakota had no active military airports. However, a variety of U.S. Army Air Corps planes made appearances at airports across the state. Sometimes they were brought to airshows, and sometimes they were just flying through. This Martin B-10 flew into Yankton and Spearfish for display. (Courtesy of Marion Havelaar.)

A Douglas B-18 airplane visited Black Hills Airport in 1939. The plane entered military service in 1936 and was based on the Douglas DC-2. (Courtesy of Cecil Ice.)

The Civil Aeronautics Act of 1938 started the Civilian Pilot Training Program, hoping to train 20,000 general aviation pilots. By 1940, South Dakota had CPT programs across the state, including Black Hills Normal, Northern State, Dakota Wesleyan, Yankton College, University of South Dakota, South Dakota State University, Huron College, and Augustana College. This picture shows planes used by the CPT program at Black Hills Normal School at Spearfish. (Courtesy of LDCLWHS.)

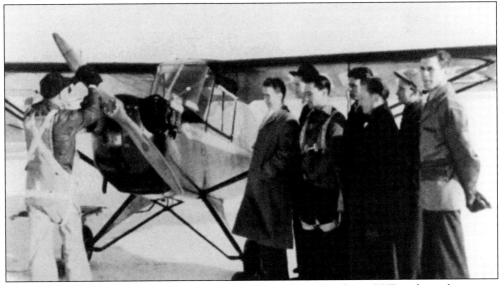

Donald Goff of Huron Flying Service, flight instructor, shows Northern CPT students the correct way to crank a plane. Students looking on are Paul Hartung, Thomas Murphy, and Harold Jones, Aberdeen; Cecil Harris, Faulkton; Charles Griffiths, Barnard; Charles Steele, Aberdeen; and Robert Pavelka, Crookston, Nebraska, all graduates of the first CPT class at Northern State Teachers College. Cecil Harris went on to be a Navy ace during World War II. (Courtesy of BWLNSU.)

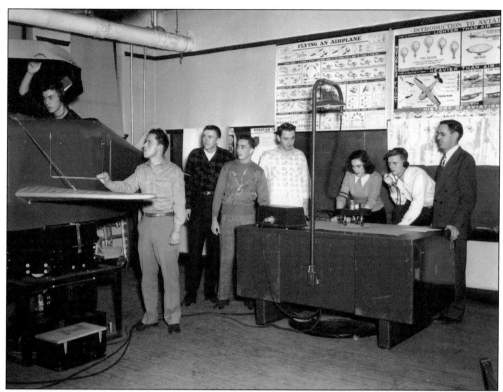

This photograph shows a class at Northern State Teachers College operating a Link Trainer. The picture dates before December 7, 1941, because there is a female student, Marjorie Callaghan, who was in the second CPT class. After the start of the war, women were no longer allowed to participate in CPT training. (Courtesy of BWLNSU.)

The CPT program had a hangar for housing its aircraft at Brookings. In front is a Curtiss Robin that was used for pilot training at South Dakota State University. (Courtesy of SDSUASP.)

This Velie Monocoupe was used at South Dakota State University for its Civilian Pilot Training Program. (Courtesy of SDSUASP.)

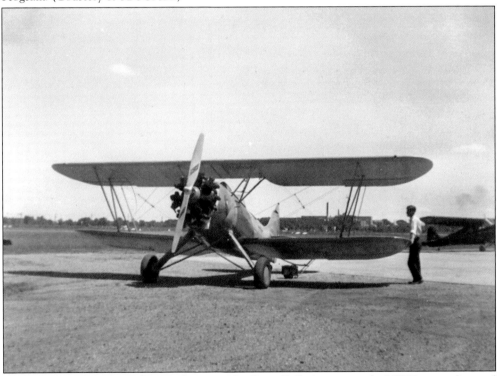

The fixed base operation of Knapp Brown at the Sioux Falls Airport used a UPF 7 as an advanced trainer for the Sioux Falls CPT program. The UPF 7 Waco was a newer airplane than those typically used in the CPT program. (Courtesy of Marion Havelaar.)

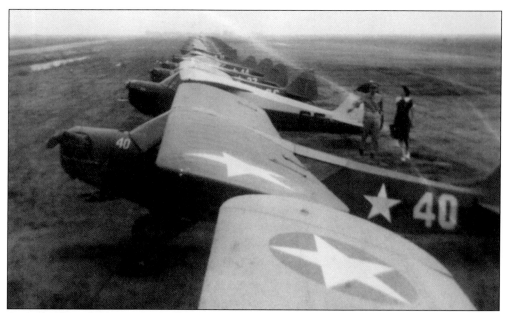

Once the United States entered World War II, the CPT programs ended and some schools worked with the War Training Service. Northern State Teachers College had a glider program and a navy pilot training program. Their 54 aircraft consisted of L2 Taylorcrafts, L3 Aeroncas, and L4 Piper Cubs, all supplied by the army. (Courtesy of BWLNSU.)

The War Training Service Program at Aberdeen generated a control tower at the airfield, a cornfield northeast of town. The army leased four quarter sections of farmland, one for a main base and the other three for practice fields. The terrain was suitable for immediate flying operations. Fort Meade at Sturgis had a ground school glider training program, but flight training was done at Alliance, Nebraska. (Courtesy of BWLNSU.)

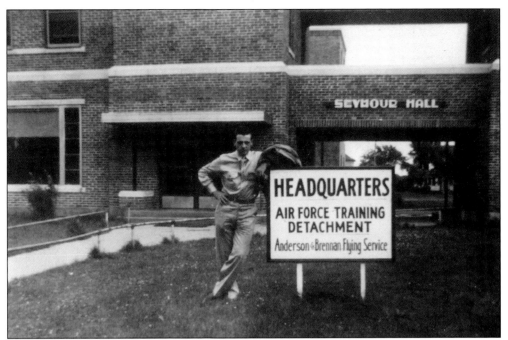

Glider pilot student Ed Keys is outside Seymour Hall, a college dorm at Northern State Teachers College, Aberdeen. The school housed and fed students and provided classroom and office space for the glider, Civilian Pilot Training, and navy training programs. Glider students flew powered airplanes, but made all landings "dead-stick." Students did not fly gliders until they transferred to their next duty station. (Courtesy of BWLNSU.)

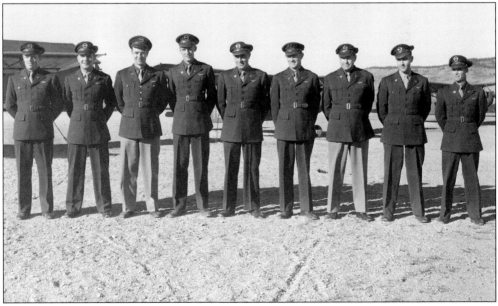

Ice Flying Service at Spearfish operated a War Training Service school in association with Black Hills Normal. Instructors were required to wear army uniforms. Pictured from left to right are Todd Oleson, Buck Davis, Eugene Kennedy, Cecil Ice, Al Kroger, Jim Fulkerson, Verne Crabtree, Don McNall, and Bart Stevens. (Courtesy of Cecil Ice.)

This photograph shows War Training Service aircraft in 1944 used for instruction at Spearfish. (Courtesy of Cecil Ice.)

The Aeronca Tiger in 1942 at Black Hills Airport is pictured here. Cecil Ice instructed in this L3 Aeronca in the Army's War Training Service flying program at Black Hills Airport at Spearfish. (Courtesy of Cecil Ice.)

The Rapid City Army Air Base was built in 1942 as a joint-use airport at Rapid City Municipal Airport. The army's operations were on the east side of the airport, while civilian operations were on the west. It was a B-17 training base, and the first B-17 landed on September 29, 1942. The airport was joint use until fall 1950. (Courtesy of MHAJM.)

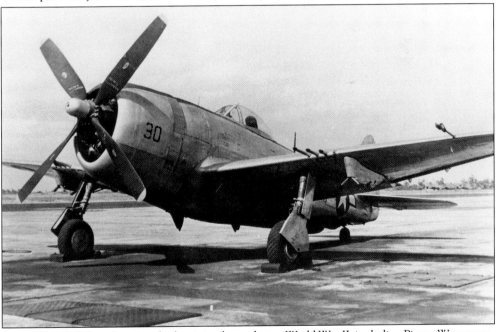

Several South Dakota locations had training bases during World War II, including Pierre, Watertown, Mitchell, Yankton, and Sioux Falls. This shows a Republic P-47 stationed at Pierre, which was considered a satellite of Rapid City Army Air Base. The Sioux Falls Army Air Base was a radio operator's training school and did not conduct flying instruction. (Courtesy of Marion Havelaar.)

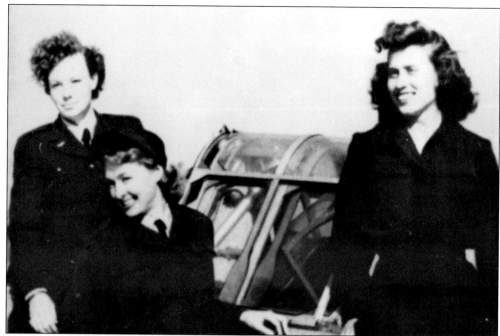

Sioux Falls Army Air Base was a Women Airforce Service Pilots (WASP) base. Pictured from left to right are Bonnie Edmunds, Brooklyn, New York; Katherine Dussaq, Dayton, Washington; and Marjorie Ellfeldt, Kansas City, Missouri. Six South Dakotans were WASPs: Laurine Nielsen, Violet Thurn Cowden, Maxine Nolt Wright, Loes Monk MacKenzie, Marjorie "Elaine" Redding Christiansen, Ola Mildred Rexroat, and Ann Ross Kary. (Courtesy of TWUCDT.)

The Civil Air Patrol served the nation during World War II by providing courier service to military bases in South Dakota. These men used their own aircraft to carry military goods and payrolls between Rapid City Army Air Base and bases at Pierre and Ainsworth, Nebraska. They were directed by the army at Fort Meade. This shows planes gathered for a ceremony near the parade grounds. (Courtesy of Lester Snyder.)

This U.S. Army Signal Corps picture shows the Civil Air Patrol at Fort Meade receiving a courier bag. Pictured from left to right are an unidentified army officer, CAP members Capt. John Moodie, Lt. Ed Anderson, Lt. Jack Davis, Lt. Ross Wiehe, Lt. Cecil Urban, Lt. Roger L'Esperance, Lt. Louie Beckwith, Lt. Max Kuehn, and Lt. Martin Schroeder. L'Esperance was an operations officer; the rest were pilots. (Courtesy of Lester Snyder.)

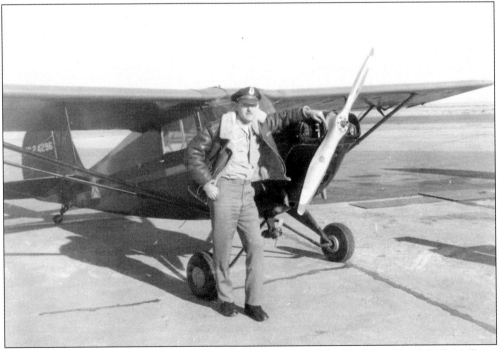

Capt. John Moodie was commander of the Rapid City Unit of the Civil Air Patrol, 2nd Air Force Courier Service, during World War II. Captain Moodie was waiting with his plane prior to loading cargo for a CAP courier route out of Pierre in January 1944. (Courtesy of Lester Snyder.)

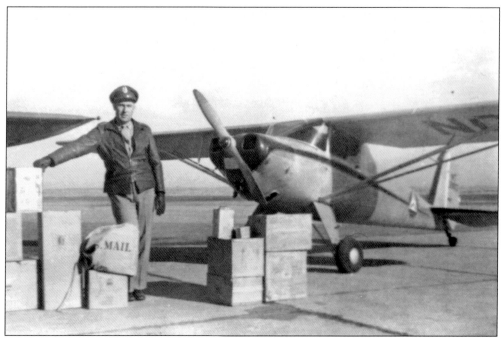

Shown here is Lt. Ross Wiehe, Civil Air Patrol courier service pilot, with his plane at Pierre in 1944. The cargo on the left is for Captain Moodie's route; cargo on the right is for Lieutenant Wiehe's route. (Courtesy of Lester Snyder.)

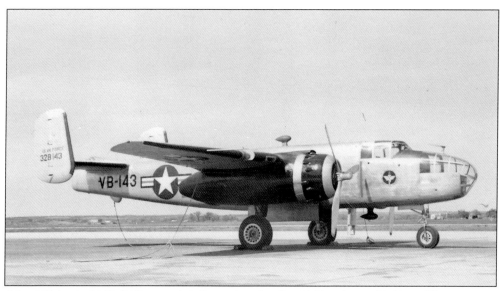

After VE day in 1945, B-25s were briefly stationed at Rapid City Army Air Base. Their mission at the base did not last. The base shut down temporarily from September 1946 to March 1947, when it reopened as Rapid City Air Force Base. (Courtesy of Luverne Kraemer.)

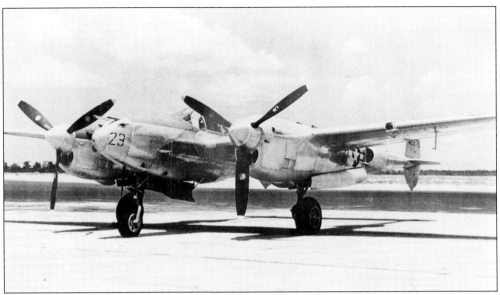

After World War II, the F5 photo reconnaissance plane was based at Rapid City Army Air Base. The F5 had the same basic design as the P-38 but was fitted with cameras. For a short time after the end of World War II, P-38s were stationed at the base to train Chinese pilots. (Courtesy of Marion Havelaar.)

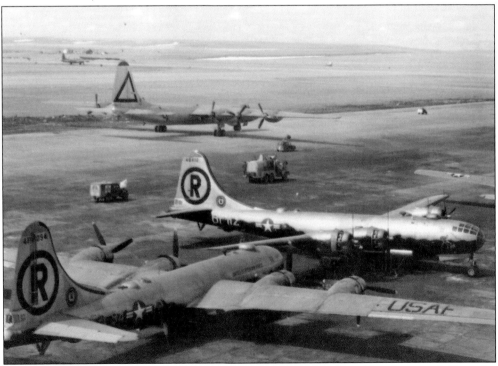

From 1945 to 1950, Rapid City Army Air Base hosted B-29 bombers (the planes with R on the tail.) The plane with the triangle on the tail is a B-36. In 1948, the base was named Rapid City Air Force Base and then Weaver Air Force Base. In 1953, it became Ellsworth Air Force Base honoring Brig. Gen. Richard E. Ellsworth, who died in a B-36. (Courtesy of LDCLWHS.)

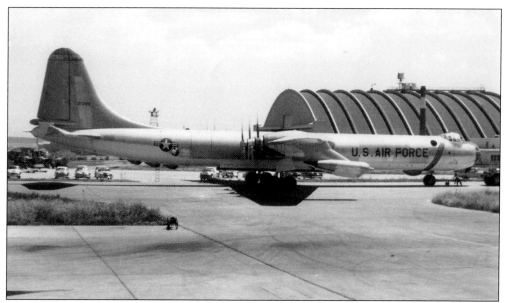

The B-36 served at Ellsworth Air Force Base from 1949 to May 1957. It started out as a propeller-driven plane with jet engines added as upgrades. This one is parked in front of the "Pride" hangar at the base. The hangar is no longer used for these mammoth aircraft; instead, the interior has been turned into offices. (Courtesy of Marion Havelaar.)

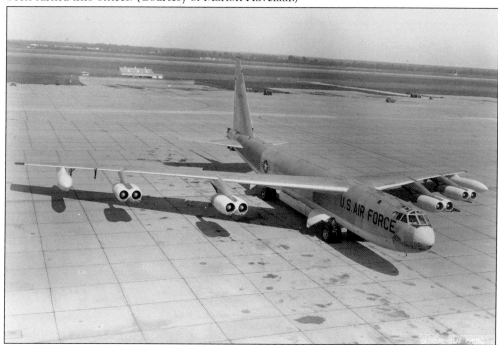

The Boeing B-52 was stationed at Ellsworth Air Force Base from 1957 to 1986. During its time at Ellsworth, it carried both conventional and nuclear weapons, evolving as the Cold War demanded. It was an improvement over the B-36 in that it had an almost indefinite range because of its air-refueling capability. By the time it left, it sported a camouflage paint scheme. (Courtesy of Marion Havelaar.)

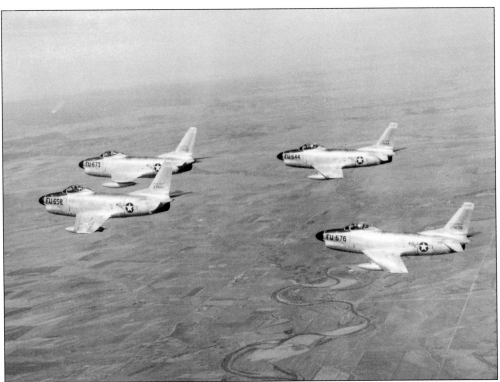

In the 1950s, the F-86D Sabre Jets were stationed at Ellsworth Air Force Base. This image shows the all-weather radar interceptors over the Black Hills. (Courtesy of Marion Havelaar.)

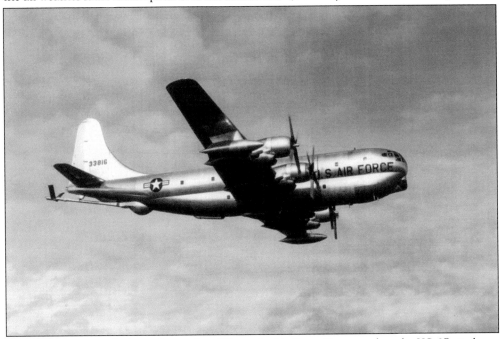

The first air-to-air refueling of aircraft at Ellsworth Air Force Base was done by KC-97 airplanes in the 1950s. (Courtesy of Marion Havelaar.)

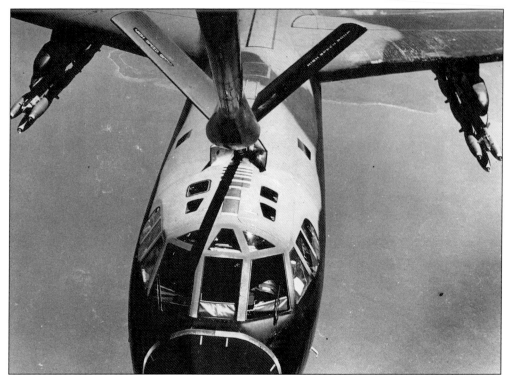

This is the view from the boom operator's position in a KC-135 aircraft as it refuels a B-52. There were also EC-135 aircraft at Ellsworth Air Force Base. These planes had an airborne aerial command post that could launch ground-based missiles. The EC-135 could also be air refueled and could deliver fuel to other airplanes. (Courtesy of South Dakota State Archives.)

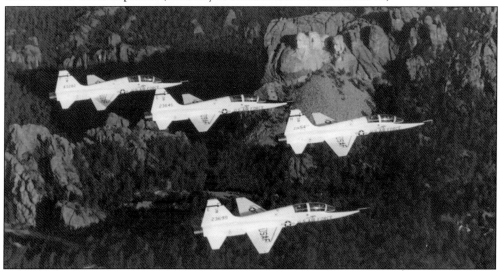

T-38s were based at Ellsworth Air Force Base to help pilots maintain currency when the cost of fuel for flying the eight-engined B-52s became prohibitive. This image shows a flight of four going by Mount Rushmore in the 1970s. Mount Rushmore is a favorite photograph opportunity for aircraft, although pilots must observe air space restrictions over the monument. (Courtesy of Marion Havelaar.)

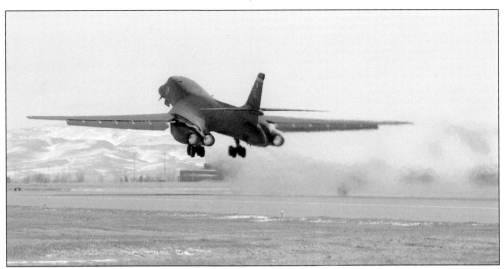

The B-1B bomber arrived at Ellsworth Air Force Base on January 21, 1986, and is currently stationed at the base. Originally designed for nuclear weapons, it has become the U.S. Air Force's premier conventional bomber. (Courtesy Ellsworth Air Force Base Public Affairs Office.)

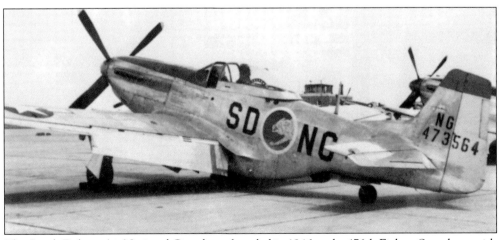

The South Dakota Air National Guard was founded in 1946 as the 176th Fighter Squadron, with Congressional Medal of Honor winner and Marine Ace Joseph J. Foss as commander of 25 P-51 Mustangs. The squadron, based at Sioux Falls Airport, also started with two C-47s, two A-26s, two AT-6s, and two L-5 Sentinels. (Courtesy of South Dakota State Library.)

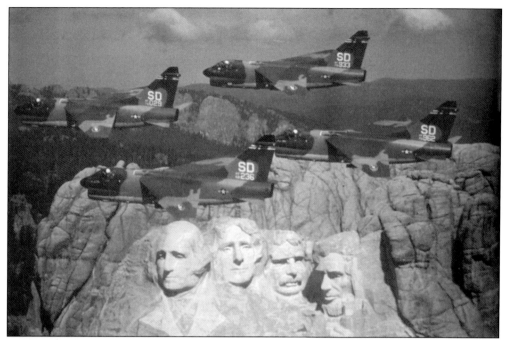

From 1954 to 1958, the South Dakota Air National Guard flew F-94s, followed by F-89 Scorpions. In 1960, the guard received F-102 Delta Daggers, replaced in May 1970 by F-100Ds. By 1977, the F-100Ds were replaced by A-7D Corsair jets. This image shows four A-7Ds in the Mount Rushmore pose. (Courtesy of South Dakota State Library.)

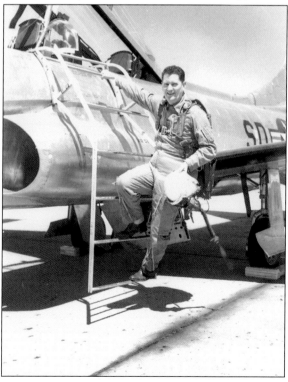

In 1954, the South Dakota Air National Guard received two T-33 aircraft to begin the transition to jets. This image shows Joe Foss on the ladder of a T-33. While Foss was a major in the Marine Corps, he eventually rose to the rank of brigadier general in the U.S. Air Force while with the South Dakota Air National Guard. (Courtesy of South Dakota Air National Guard.)

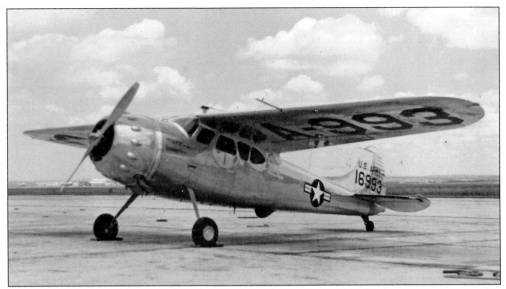

The South Dakota Army Guard used a Cessna 195 starting in 1947. In this picture, it is on the ramp at Rapid City Municipal Airport with the air force's buildings visible in the background. The airport was used jointly with the air force. The army's South Dakota National Guard maintains its own aviation operations separate from the air guard. (Courtesy of Luverne Kraemer.)

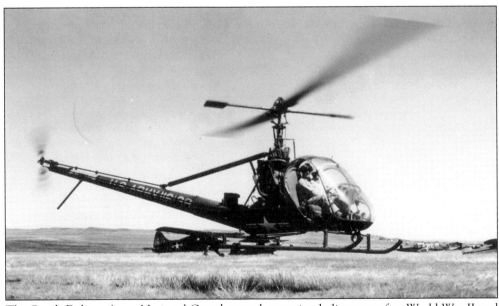

The South Dakota Army National Guard started operating helicopters after World War II and based its operation at Halley Airport at Rapid City. Its first helicopter was a Hiller H-23. In the background is an L-20 Beaver that the army guard used as personal transportation for General Arndt. Donald Effinger piloted the L-20. (Courtesy of Marion Havelaar.)

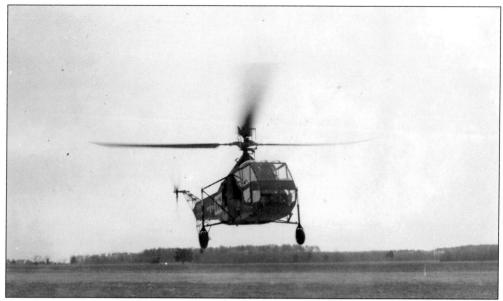

Another early helicopter operated by the South Dakota Army National Guard was a Sikorsky R4, also based at Halley Airport. (Courtesy of Luverne Kraemer.)

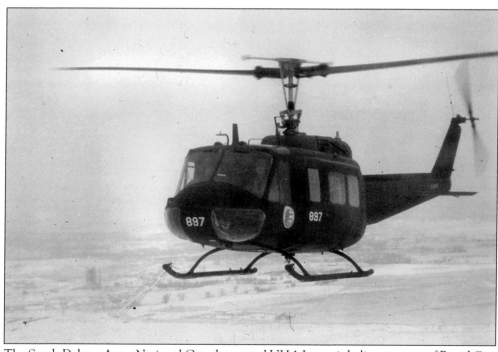

The South Dakota Army National Guard operated UH-1 Iroquois helicopters out of Rapid City Regional Airport during the 1970s and 1980s. They were especially useful in fighting forest fires. The air force also used UH-1 helicopters at Ellsworth Air Force Base during the same era to support operation of Minuteman missiles buried all over western South Dakota. (Courtesy of Norma Kraemer.)

Five

A MULTITUDE OF UNIQUE USES

South Dakotans have found many wonderful uses for aircraft. Since the state's main economic engine is agriculture, it is not surprising that aircraft in a wide range of sizes are used for everything from predator control to aerial application. Ranchers also take to the skies to check on their cattle, covering the huge areas typical of western South Dakota ranches in their private aircraft.

During the uranium boom of the 1950s, prospectors even used aircraft to search for this valuable element commonly found in western South Dakota. Others fly to herd animals, including the buffalos in the annual roundup at Custer State Park.

Aerial firefighters are vital to the task of keeping the Black Hills National Forest and surrounding prairies from turning to ashes. Quick responses are possible from planes ranging from single-engine air tankers to mammoth, multi-engine aircraft capable of carrying large loads of fire retardant.

Engineers have embraced aircraft by using them for aerial mapping. Today an airplane can fly over a mine, take pictures, and produce a report within 24 hours that can quantify how much has been dug out of the pit and how much overburden has been removed. Aerial surveys also play a crucial role in construction planning.

South Dakota's rural environment makes access to services, especially emergency medical services, a challenge. Operators in both Sioux Falls and Rapid City now offer fixed-wing and helicopter aircraft services that provide state-of-the-art medical care, providing people in remote areas with a better chance of surviving a medical emergency.

The tourism industry also benefits greatly from aviation. People can sightsee by helicopter, airplane, or hot air balloon, while commercial airlines and private aircraft bring visitors to the state.

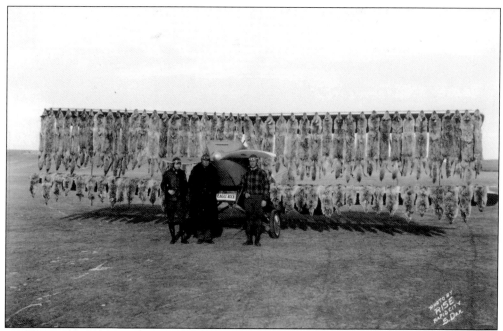

Clyde Ice was quick to find new uses for airplanes. Predator control with open cockpit Alexander Eaglerock biplanes was a boon to ranchers wanting to protect their livestock from coyotes. From left to right are Charlie Orlup (gunner), Clyde Ice (pilot), and Earl Wilson (gunner), with the 75 coyote hides they collected in 1928. (Courtesy of Howard Ice.)

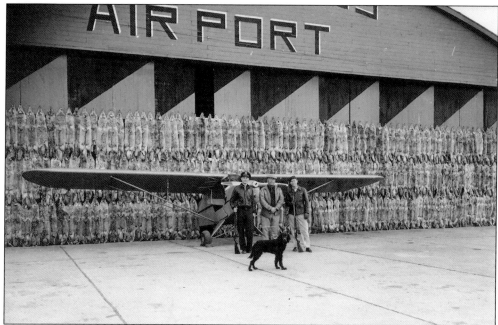

High-wing Piper J-3 Cubs and similar monoplanes have become the preferred aerial hunting platform. This 1944 picture shows 320 coyote hides nailed to the hangar door at Black Hills Airport at Spearfish. From left to right are Cecil Ice, Clyde Ice, and an unidentified gunner. Clyde would fly while his gunner hopefully hit the coyote and not the propeller. (Courtesy of Cecil Ice.)

The state's largest industry is agriculture. Aircraft are used for application of pesticides and seeds vital to agriculture's success. This image shows Mark Breuer in 1949 at Howard, with a Stearman PT-17 outfitted with a duster hopper. He used this for a time spreading pellet fertilizer and sowing a few fields of rye on the Bob and Vince Breuer farm in Miner County. (Courtesy of Mark Breuer.)

This image shows the loading of the rye seed into the hopper of the Stearman PT-17 by Mark Breuer. The picture was taken in 1949 at Howard. Mark is on the wing. (Courtesy of Mark Breuer.)

Mark Breuer is using a 1946 Piper J-3 Cub to spray grain in 1952 near Howard. To prevent mishaps, pilots must beware of hazards such as power lines and the shelter belts planted around fields. (Courtesy of Mark Breuer.)

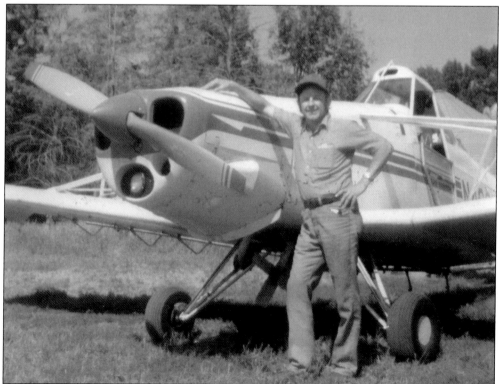

By 1977, Breuer Aerial Spraying was using a 1968 Piper Pawnee. (Courtesy of Mark Breuer.)

A newspaper advertisement from the 1980s for Breuer Aerial Spraying shows various uses for aerial application. (Courtesy of Mark Breuer.)

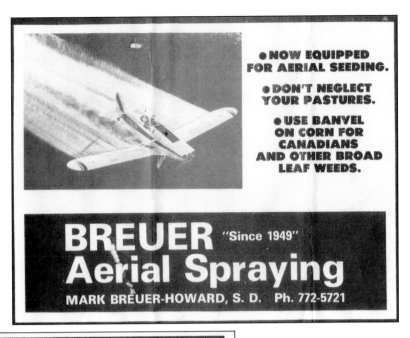

Aerial applicators advertised their services using posters such as this one from the 1940s. Clyde Ice's Black Hills Flying Service reached a large area of South Dakota and Wyoming, offering local phone numbers in Spearfish, Pierre, Belle Fourche, and in Newcastle, Wyoming. (Courtesy of Luverne Kraemer.)

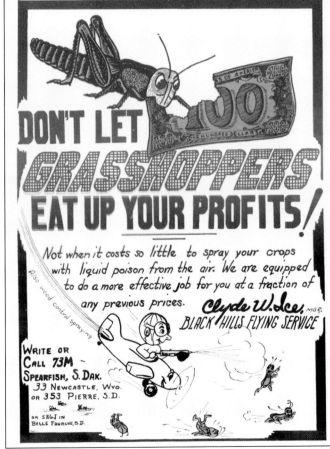

Clyde Ice was using this Piper PA-11 in 1985 to spray crops. Clyde had a long flying career and was still crop dusting into his 80s. He passed his enthusiasm for flying on to many of his children, with sons Randall, Howard, and Cecil making their living in aviation. (Courtesy of Luverne Kraemer.)

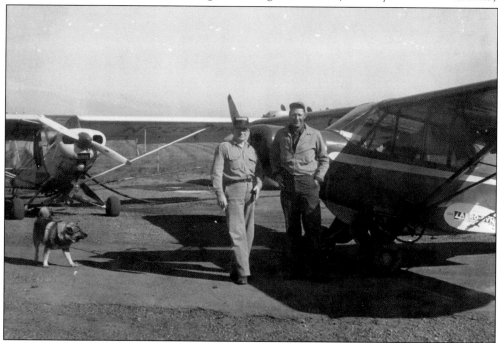

This image shows one of Cecil Ice's Piper PA-18 sprayers with an Aero-Dyne tank system installed. The tank, installed under the belly of the plane, had its own wing as part of the structure. The spray booms extend from the tank system below each wing. Cecil Ice is on the right. (Courtesy of Cecil Ice.)

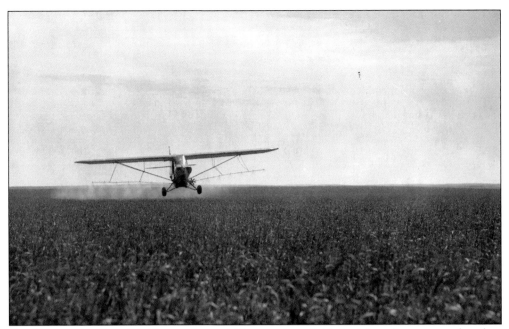

Cecil Ice uses his Piper PA-11 to apply pesticide to a wheat field. Aerial applicators must be adept at flying low, and they must often fly early in the morning or in the evening, when there is little wind to disperse the substance being applied. (Courtesy of Cecil Ice.)

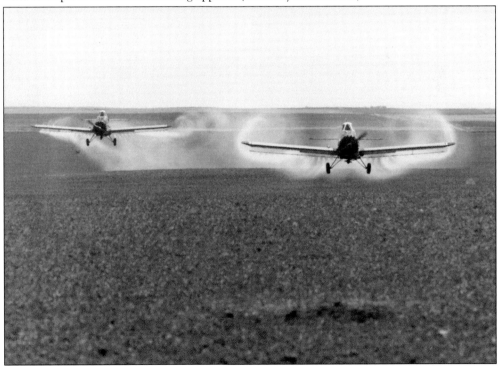

The large fields of South Dakota are well suited for agricultural airplanes to fly in formation, covering fields efficiently. This image shows two of Cecil Ice's aircraft covering a field. (Courtesy of Cecil Ice.)

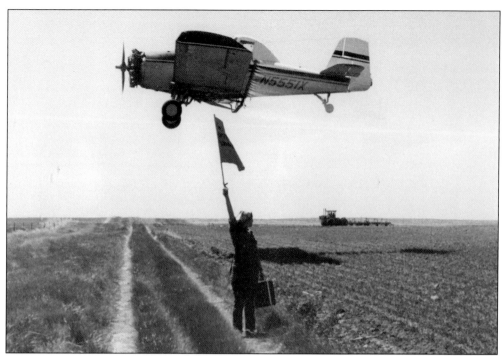

To track position in a field, flag people are used. Here one of Cecil Ice's helpers, Linda Ehrenfelt, carries a flag as well as the photographer's camera equipment. Flaggers have to be quick on their feet to get out of the way if oncoming aircraft are too low. Today they can be replaced by automatic flag drop boxes mounted on wings or GPS units. (Courtesy of Cecil Ice.)

Agricultural pilots must be able to make tight turns to make sure they thoroughly cover the field with their spray. (Courtesy of Cecil Ice.)

Cecil Ice's Air Tractor 602 is spraying a sunflower field. The turbine-powered Air Tractor 602 can carry a 630-gallon load, allowing it to replace two smaller aircraft and make the operation more cost effective. (Courtesy of Cecil Ice.)

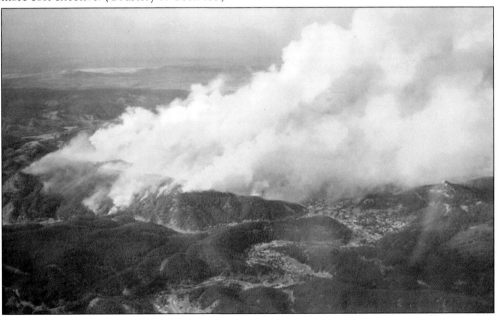

Arnold Kolb operated Black Hills Airport from 1958 to 1972. The Deadwood Fire of 1959 in this picture sparked his interest in aerial firefighting. His operation flew charter, air ambulance, game census, crop dusting, instructing, uranium prospecting, corralling of antelope and wild horses, cloud seeding, and scenic flights. He is probably best known as a major national provider of aerial firefighting aircraft. (Courtesy of Arnold Kolb.)

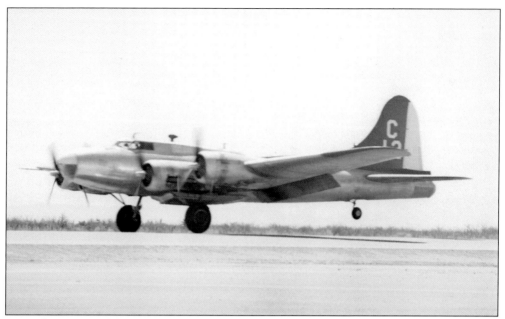

Forest fires require different size doors to apply fire retardant than do grass fires. In 1964, Kolb's Black Hills Aviation modified Boeing B-17s as slurry bombers. Kolb worked with the Forest Service, Bureaus of Land Management and Indian Affairs, and the National Park Service. The plane could be loaded with 2,000 gallons in 5 minutes and be airborne within 15 minutes of being called. (Courtesy of Arnold Kolb.)

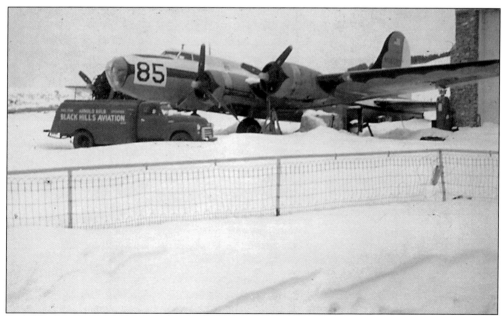

Over the winter, Black Hills Aviation performed maintenance on its slurry bombers. However, the old stone hangar at Black Hills Airport was not large enough to house the B-17, so work was done out in the elements. This hangar was demolished to make way for U.S. Interstate 90. (Courtesy of Arnold Kolb.)

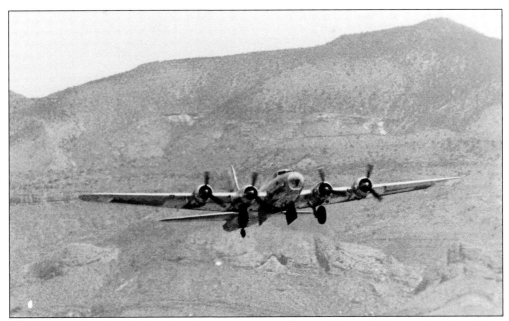

The fire retardant that the bomber drops is a mixture of water, clay, and diammonium phosphate. The mixture does not put the fire out but keeps the material it clings to from burning. Because U.S. Interstate 90 was built through Black Hills Airport in 1972 and shortened the runway, Kolb moved his base of operations to Alamogordo, New Mexico. The company name remained Black Hills Aviation. (Courtesy of Arnold Kolb.)

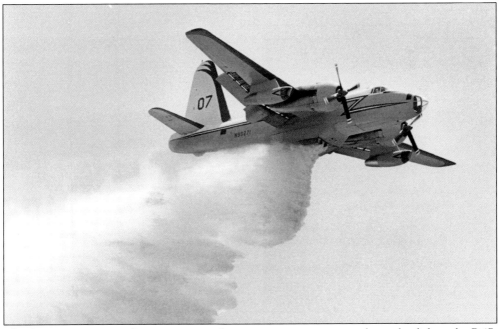

The forest service started requiring aircraft in its contracts to carry a larger load than the B-17s could carry. In 1974, Arnold Kolb obtained four derelict surplus Lockheed P2V Neptunes to rebuild and put into service. They could carry a load of 2,800 gallons of retardant, although typical loads were 2,500 gallons. By 1984, the B-17s were retired. (Courtesy of Arnold Kolb.)

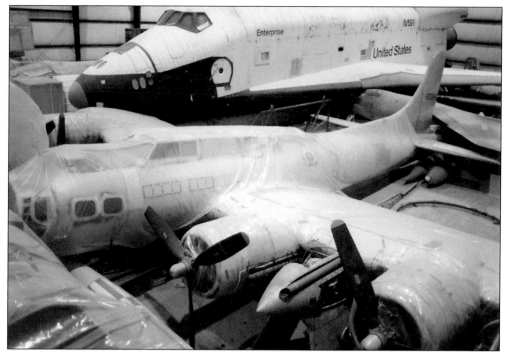

The Kolb B-17 was flown to Dulles Airport by Arnold and Nathan Kolb before the Smithsonian's new Air And Space Museum annex was completed, so it was stored with other notable aircraft, including the space shuttle *Enterprise*. However, the Smithsonian chose to loan the airplane to the Mighty Eighth Air Force Museum in Savannah, Georgia, where it is the museum's centerpiece display. (Courtesy of Arnold Kolb.)

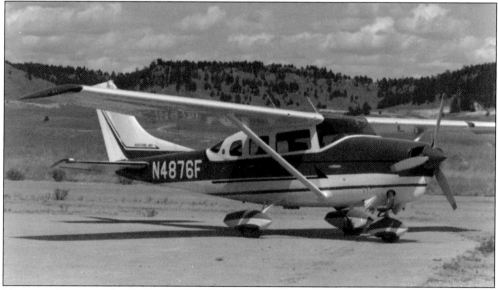

Horizons, Inc. started in 1968 in Rapid City at the Lien Airport, providing aerial photography and photogrammetry services. Founder Fred Brady used a Piper Cub holding a camera out the window. By 1973, he had a Cessna 206 with a camera mounted in the aircraft belly. In 1970, it cost $20,000 to get FAA certification for camera installation. (Courtesy of Fugro Horizons, Inc.)

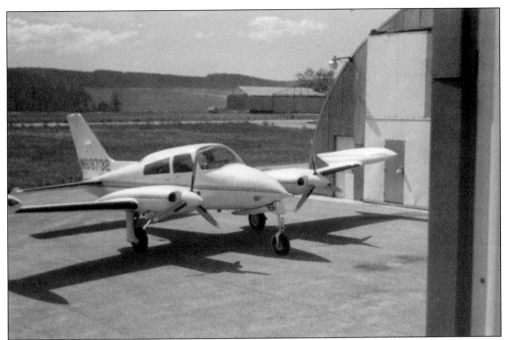

When moving up to multi-engine aircraft, Horizons first used a Cessna 310, shown at the Lien Airport hangar. It was equipped for regular, infrared, and topographic photography. Planes are also modified with STOL (Short Takeoff and Landing) kits and beefed up engines to give better performance and speed. By 1987, Horizons based operations at Rapid City Regional Airport. (Courtesy of Fugro Horizons, Inc.)

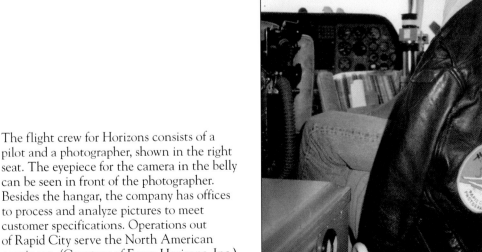

The flight crew for Horizons consists of a pilot and a photographer, shown in the right seat. The eyepiece for the camera in the belly can be seen in front of the photographer. Besides the hangar, the company has offices to process and analyze pictures to meet customer specifications. Operations out of Rapid City serve the North American continent. (Courtesy of Fugro Horizons, Inc.)

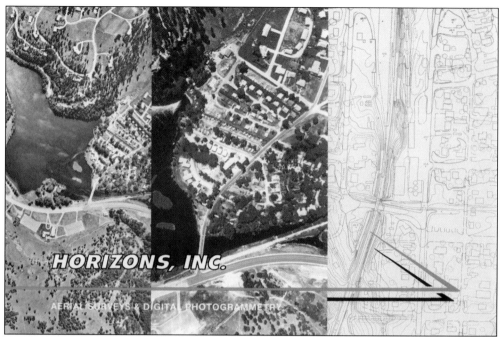

An early brochure shows Horizon's capabilities of regular, infrared, and topographic photography products. In 2007, Netherlands engineering firm Fugro, N. V. acquired Horizons, making them part of the world's largest providers of onshore and offshore data. Until recently the company relied on large format film cameras. Now digital, GPS, and laser equipment has been added. (Courtesy of Fugro Horizons, Inc.)

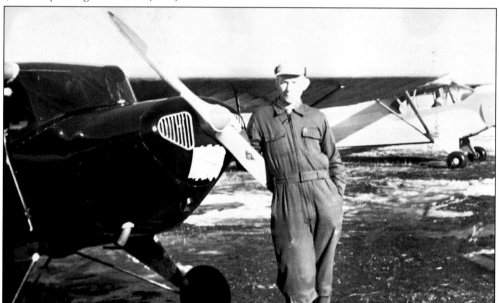

Like many helpful pilots in South Dakota, Clarence Hansen used his Taylorcraft to fly a child bitten by a rattlesnake to a hospital. The airplane's utility in times of crisis eventually led to real air ambulance service in the state. Clarence established Platte's airport in 1940 and was part of the postwar flying boom with the GI bill letting veterans earn their wings. (Courtesy of Ken Hansen.)

Intensive Air at Sioux Valley Hospital in Sioux Falls started in 1977 with a grant to reduce high infant mortality rates in rural areas of the state. It chartered a Piper Lance to start, but by 1982, the company was using its own dedicated Cessna 401, pictured, and a Beech King Air 90, as air ambulances. (Courtesy of Sanford Intensive Air.)

By 1986, Sioux Valley Hospital had added rotor wing transport with an Agusta helicopter. This complemented existing transport service with accident and scene response. The helicopter was leased from Rocky Mountain Helicopters of Provo, Utah. Before it received the Agusta, the program used an Alouette helicopter. By 1989, Intensive Air was operating under a Part 135 certificate, adding the helicopters to the certificate in 1998. (Courtesy of Sanford Intensive Air.)

Jerry Dale started Medical Air Rescue in Rapid City in 1982 by obtaining a Part 135 certificate. He used a Cessna 402 designed to be an air ambulance with a stretcher system and life support equipment installed in the plane. (Courtesy of Dale Aviation.)

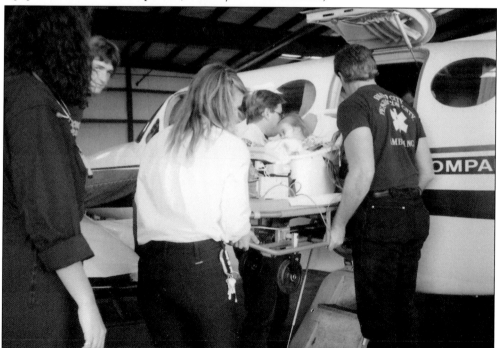

Most Rapid City patients were transported to larger medical centers in the 1980s. This shows a pair of twins being loaded for transport to Denver Children's Hospital in 1987. Over time, as Rapid City Regional Hospital has become more diverse in its capabilities, people are airlifted to Rapid City for care. (Courtesy of Dale Aviation.)

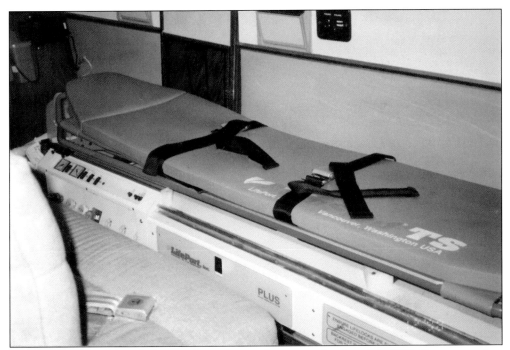

Medical Air Rescue's Randy Rosane devised a stretcher system for aircraft in 1988. Oxygen, suction, and basic medical systems are built into the base, creating a life support unit. The patient can be loaded through aircraft doors, and the system fits on the seat rails of the plane. Approximately 90 percent of fixed-wing air ambulances use it, marketed as AeroSled by LifePort, Inc. (Courtesy of Dale Aviation.)

Bruce Schiltz started giving helicopter rides to tourists in 1960 at Al's Oasis near Chamberlain. He had earned his commercial helicopter rating in Huron in 1959. His Bell 47 was the second privately owned helicopter in South Dakota. (Courtesy of Bruce Schiltz.)

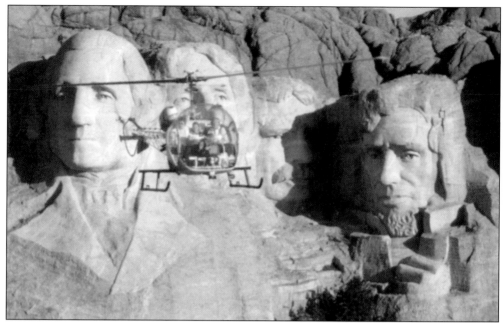

Starting in 1961, Bruce Schiltz used his Bell 47 helicopter to give tourists rides from Keystone to see Mount Rushmore, providing a unique view of South Dakota's most well-known attraction. The Bell was replaced by a Hughes in 1983. While Bruce operated the flights, he flew more than 150,000 trips without an accident. (Courtesy of Bruce Schiltz.)

Part of the helicopter ride experience at Keystone includes a souvenir photograph. Pictured from left to right are Dewey and Florence Schiltz with son Bruce as pilot. (Courtesy of Bruce Schiltz.)

Six

GOVERNMENT'S VITAL ROLE IN AVIATION

Aviation would not be such an integral part of our daily lives without the help of government to provide safe take-off and landing facilities. South Dakota's government bodies were slow to recognize they should be involved. While Newell provided a space for an airport in its 1910 master plan, most government agencies dragged their feet in supporting airports. Aberdeen is credited with having the first airport in South Dakota, built by its fairgrounds in 1921. The state became firmly involved in 1935 with the establishment of the South Dakota Aeronautics Commission. It continues to promote airport and airway development statewide.

The federal government did little to help aviation in the state until the establishment of radio stations at flight service stations in 1939. Advertisements in aviation magazines showing radio navigation aids across the United States until 1939 show South Dakota and Montana ignored by radio beacons. World War II brought a flurry of flight service stations, only to see them disappear gradually until none were left in 2005. Now there are two civilian air traffic control towers in the state and the Federal Aviation Administration oversees pilots, aircraft owners, and operators, as well as agricultural operators and repair stations. The Black Hills National Forest has put aircraft to good use in suppressing forest fires since 1959. The agency primarily uses helicopters for operations but calls in the slurry bombers when appropriate.

South Dakota state schools offer professional courses for pilots and mechanics, and they use aircraft for scientific research that is at the leading edge. The research conducted by the Institute for Atmospheric Sciences has even had its T-28 aircraft featured on The Weather Channel.

Government involvement in aviation makes it better for all.

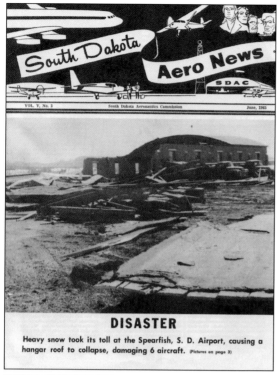

The South Dakota Aeronautics Commission was established in 1935 to promote aviation and register residents' pilot licenses and aircraft. Since 1950, the agency has published a state aeronautical chart and airport directory. The newsletter, *Aero News*, ran for about 30 years starting in 1960. The agency coordinates funding with the Federal Aviation Administration for airports throughout the state. Commission funding comes from an aviation fuel tax and registration fees. (Courtesy of Arnold Kolb.)

DISASTER

Heavy snow took its toll at the Spearfish, S. D. Airport, causing a hangar roof to collapse, damaging 6 aircraft. (Pictures on page 3)

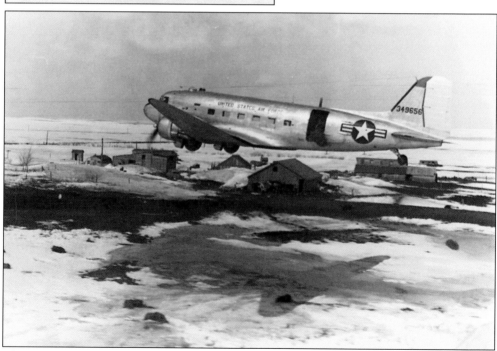

The state coordinated blizzard relief by aircraft in 1952 to feed cattle stranded in the wide open prairies of South Dakota. A C-47 dropped hay to cattle out of the Pierre airport. The U.S. Army and Air National Guard units helped, as well as Ellsworth Air Force Base. Airdrops were also made after the blizzard of 1949. (Courtesy of South Dakota State Archives.)

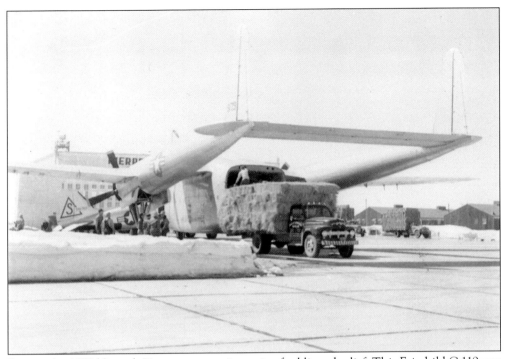

During the 1952 blizzard, Pierre was a staging point for blizzard relief. This Fairchild C-119 was loaded with hay and flown to cattle stranded by the blizzard. Note the deep snow plowed from the apron. Over the years, aircraft have also brought relief to pheasants when the snow cover is heavy in eastern South Dakota's Huron area. (Courtesy of Marion Havelaar.)

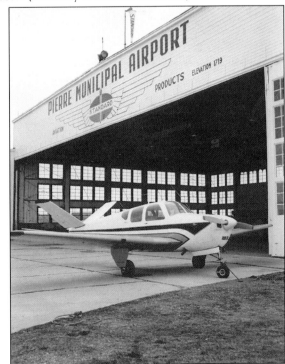

The State of South Dakota obtained a Beech Bonanza in the 1940s to fly the governor around the state. The aeronautics director also served as the chief pilot for many years. Airplanes were stored in the large hangar from World War II at the Pierre Army Air Base. (Courtesy of South Dakota State Archives.)

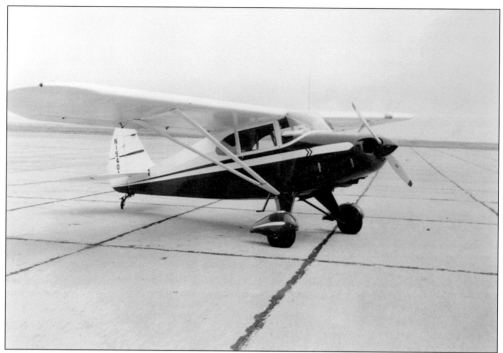

The State of South Dakota also had a Piper PA-20 for use in the 1950s. Today the governor is flown on business in a King Air. (Courtesy of South Dakota State Archives.)

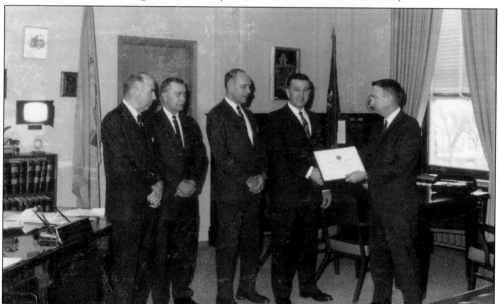

In 1969, the South Dakota Aeronautics Commission honored the state's Federal Aviation Administration mechanic of the year, Luverne Kraemer, at Governor Farrar's office. From left to right are Keith Anderson, flight service station, Pierre; Clay Feldhausen, supervisory inspector, General Aviation District Office, Rapid City; Lynn Hanson, director of the Aeronautics Commission, Pierre; Luverne Kraemer; and William Ramsey, assistant area manager, FAA, Minneapolis, Minnesota, at the state capitol. (Courtesy of Luverne Kraemer.)

Flight service stations in South Dakota first opened in 1939 at Huron and Sioux Falls. In 1940, Watertown and Aberdeen opened; Rapid City, Pierre, and Spearfish opened in 1941; and Philip in 1942. Stations provided weather information to pilots, recorded flight plans, and offered written exams for licenses. This 1950s picture shows typical station teletype and radio equipment used by flight service briefers. (Courtesy of Jack Mitchell.)

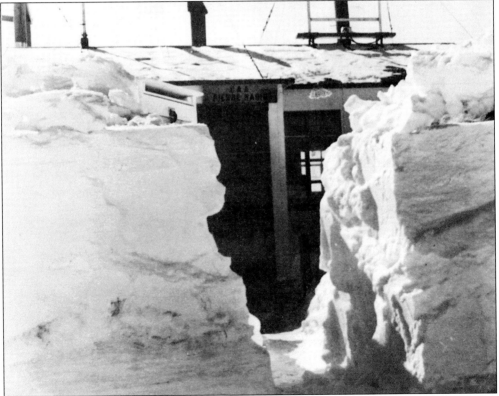

The blizzards that affect livestock in the state also challenge human life. This image shows the Pierre Radio building after the blizzard in 1952. At this time, the Civil Aeronautics Administration (CAA) regulated aviation in the United States. In 1958, the name changed to Federal Aviation Agency, and in 1966, it became the Federal Aviation Administration. (Courtesy of Jack Mitchell.)

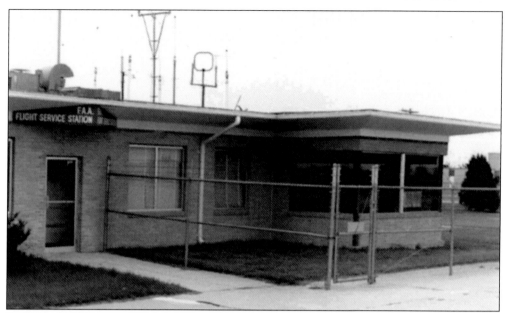

By 1986, the Watertown Flight Service Station was in a modern brick building that replaced the old World War II building. (Courtesy of Jim Anez.)

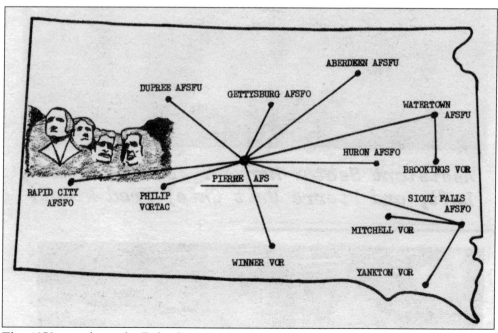

This 1972 map shows the Federal Airway Facilities Sector based in Pierre. Its 45 employees maintained 77 air navigation and air traffic facilities covering the entire state of South Dakota. There were field units in Aberdeen, Gettysburg, Huron, Sioux Falls, Dupree, Watertown, and Rapid City. Usually offices were in the same building as flight service stations and/or the Flight Standards District Office. (Courtesy of Jack Mitchell.)

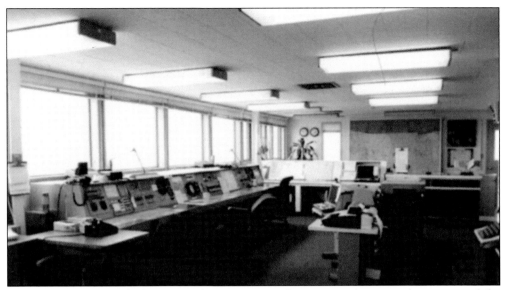

Flight service briefers had more modern equipment by 1990, as shown in this picture of the Pierre Flight Service Station. Teletype equipment had been replaced by computers. Pilots were still allowed to visit with the briefer in person and look at maps and weather reports, as well as file their flight plans. (Courtesy of Jim Anez.)

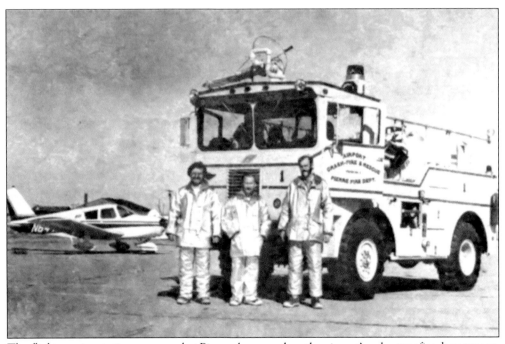

The flight service station personnel at Pierre also served on the airport's volunteer fire department. The department was organized in 1975 and also had volunteer members from town. They had to be at the airport 15 minutes before each scheduled airline flight. From left to right are flight service personnel Court Bailey, Jack Mitchell, and Phil Rhode with the airport crash, fire, and rescue truck. (Courtesy of Jack Mitchell.)

In 1986, the Huron Flight Service Station built its third office, with modern equipment for the computer age. In 1993 and 1994, the remaining stations in the state, Pierre, Rapid City, Watertown, and Aberdeen, were consolidated into Huron. In 2005, Huron was closed and all services transferred to Princeton, Minnesota, under a contract awarded to Lockheed Martin. (Courtesy of Jim Anez.)

The current terminal at the Pierre Airport was built in 1960. At the time, it was served by North Central and Western Airlines. This picture shows the Pierre air carrier ramp and flight service station in 1990. The FSS was upstairs and the passenger terminal and a restaurant were on the ground floor when the terminal was built. (Courtesy of Jim Anez.)

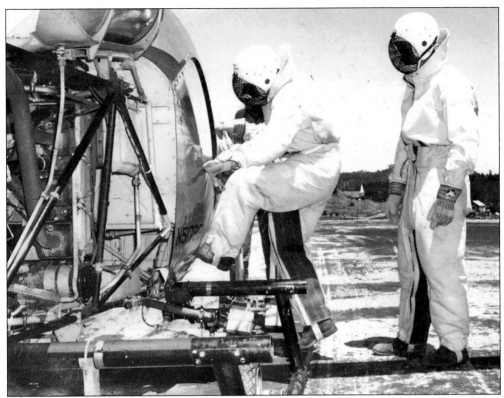

Helicopters started fighting forest fires in the Black Hills in 1959. The smoke jumpers were flown into a fire and jumped without benefit of rappelling or parachutes from a low altitude. This image shows the first crew of smoke jumpers. Firefighters wore the same safety equipment as in Montana. Equipment was carried on the aircraft's skids. Smoke jumpers were discontinued in 1969. (Courtesy of Black Hills National Forest.)

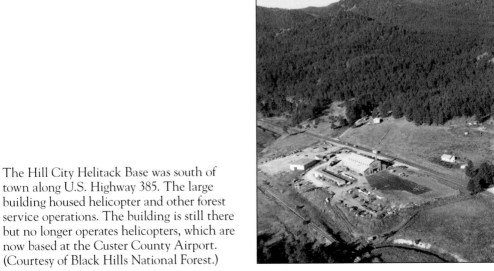

The Hill City Helitack Base was south of town along U.S. Highway 385. The large building housed helicopter and other forest service operations. The building is still there but no longer operates helicopters, which are now based at the Custer County Airport. (Courtesy of Black Hills National Forest.)

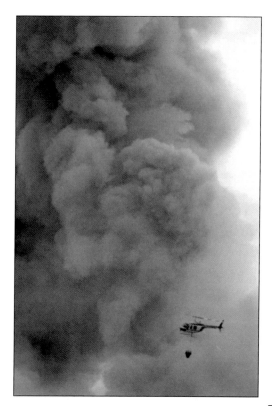

Since 1969, the forest service's helicopter operations have been used for fire spotting and to use sling-loaded buckets to douse the fire with water. Ground fire crews will set up portable tanks for filling the buckets if a water source, such as a pond or lake, is not available. (Courtesy of Black Hills National Forest.)

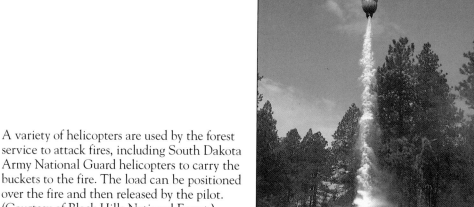

A variety of helicopters are used by the forest service to attack fires, including South Dakota Army National Guard helicopters to carry the buckets to the fire. The load can be positioned over the fire and then released by the pilot. (Courtesy of Black Hills National Forest.)

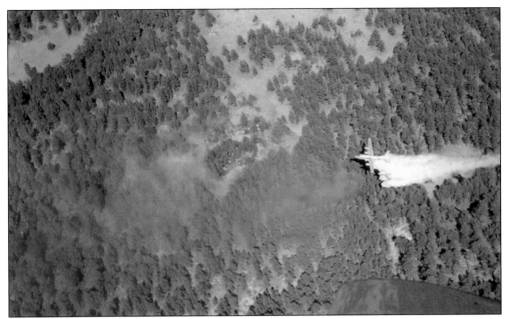

The forest service also deals with private contractors to provide slurry bomber flights over the Black Hills. While this started at Black Hills Airport in Spearfish in the 1960s, operations moved to Rapid City Regional Airport in the early 1970s. The slurry bomber can typically be directed in by a smaller spotter plane. (Courtesy of Black Hills National Forest.)

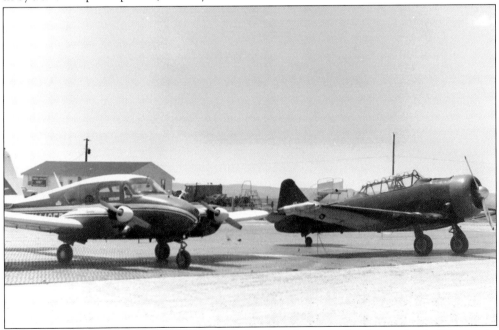

The South Dakota School of Mines and Technology Institute for Atmospheric Sciences in Rapid City started research on weather modification in 1965. Dr. Richard A. Schleusener was the first full-time director in 1964. From left to right are a Piper Apache and a Navy SNJ. They were fitted with silver iodide burners to seed clouds. The building in the background is labeled Federal Aviation Agency. (Courtesy of SDSMTIAS.)

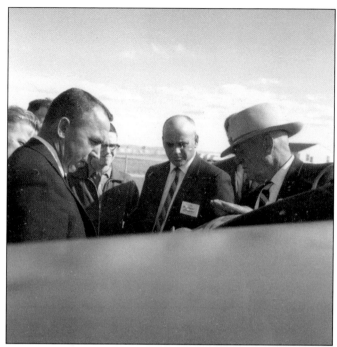

Wilbur Brewer (center) and Congressman E. Y. Berry (right) view the weather modification instrumentation at Rapid City Regional Airport in 1965. Berry and Senator Karl Mundt obtained funding from Congress. This was under the auspices of the Bureau of Reclamation's "Project Skywater." Wilbur Brewer ran weather modification programs from Bowman, North Dakota, after the initial research programs at South Dakota School of Mines and Technology. (Courtesy of SDSMTIAS.)

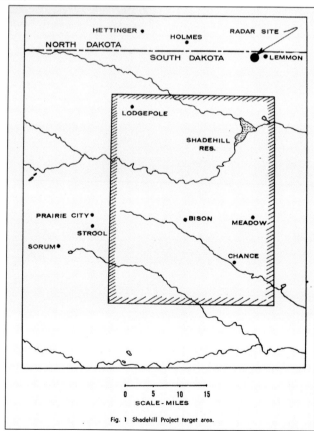

Fig. 1 Shadehill Project target area.

This map shows the 1965 weather research area at Shadehill Reservoir conducted by the South Dakota School of Mines and Technology's Institute for Atmospheric Sciences in the northwest part of the state. (Courtesy of SDSMTIAS.)

These hail stones were collected at the Shadehill research project in 1965. Weather modification was a desired outcome of the research, especially suppression of hailstorms that destroy crops. People wanted rain but not hail. Researchers wanted to see if the use of cloud seeding could reliably produce such results. (Courtesy of SDSMTIAS.)

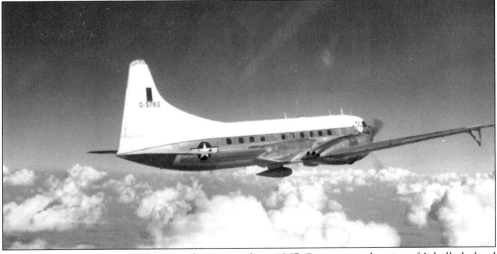

An air force DC-6 was used for weather research in 1967. Sensors on the aircraft's belly helped establish the extent to which cumulus clouds in the northern Great Plains can be modified to increase rainfall and suppress hail. Partly as a result of this research, the South Dakota legislature funded an operational cloud seeding program from 1972 to 1976. (Courtesy of SDSMTIAS.)

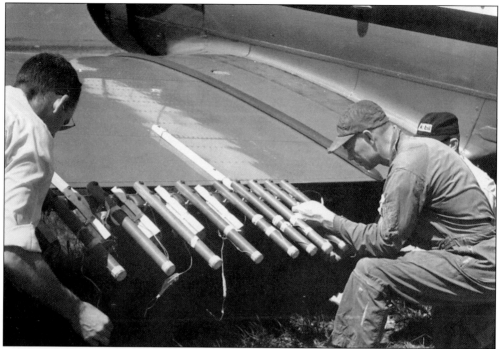

Silver iodide burners were used at Lemmon, South Dakota, in 1967. In summer 1966, a project called Hailswath was hosted in Rapid City. At the same time, the Rapid Project studied cloud seeding effects on convective rain showers. The Rapid Project continued through 1968, to be supplanted by Project Cloud Catcher from 1969 to 1972. Basic laboratory and numerical modeling studies were also performed. (Courtesy of SDSMTIAS.)

The Institute for Atmospheric Sciences used a mobile research trailer at Shadehill Reservoir in northwestern South Dakota that worked with aircraft in 1965. The house trailer provided space for a field office and living quarters. It also housed radar equipment. (Courtesy of SDSMTIAS.)

The Institute for Atmospheric Sciences acquired the T-28 research aircraft in 1969, adding 700 pounds of armor plating to the leading edges for severe weather penetration. The T-28 has done research all over the world. Although the instrument packages have changed over the years, the weather research has resulted in degree programs through the doctoral level at the South Dakota School of Mines and Technology. (Courtesy of SDSMTIAS.)

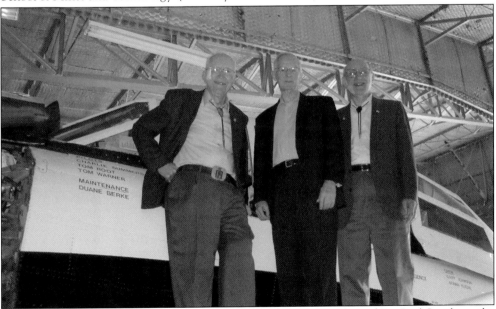

From left to right are Dr. Richard Schleusener, Dr. Paul MacCready, and Dr. Paul Smith on the wing of the T-28 in the hangar at Rapid City. Dr. Schleunsener went on to become president of the South Dakota School of Mines and Technology. Dr. MacCready was project consultant from the beginning until his death in 2007. Dr. Smith is now the director of the Institute for Atmospheric Sciences. The plane was retired in 2005, and they are looking for an A-10 as a replacement aircraft. (Courtesy of SDSMTIAS.)

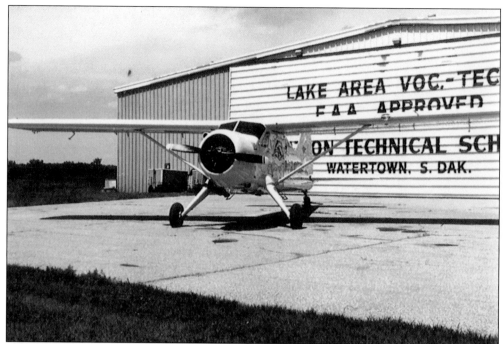

The aviation maintenance technology program was one of the first two programs at Lake Area Technical Institute in Watertown. By 1969, classes were being held in the new hangar and classroom building. Powerplant classes were initially held downtown, and the airframe classes in a World War II air base hangar. Students rebuilt the Dehavilland Beaver and sold it to fund other student projects. (Courtesy Lake Area Technical Institute.)

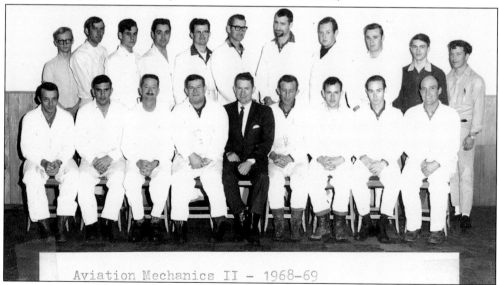

Aviation Mechanics II – 1968-69

This is a class picture with instructor Pete Tanis in the first row, center. Pete Tanis and Herb Normandy were the first instructors at the school. Normandy was the department chair until his retirement in 1977, and Tanis left the school to establish Tanis Heater Systems, arguably the number one choice for general aviation aircraft operators for cold-weather engine pre-heater systems. (Courtesy of Lake Area Technical Institute.)

Ed Shell, left, pictured with a student, began as an instructor at Lake Area Technical Institute in 1968. In 1977, he became department chair until his retirement in 1995. (Courtesy of Lake Area Technical Institute.)

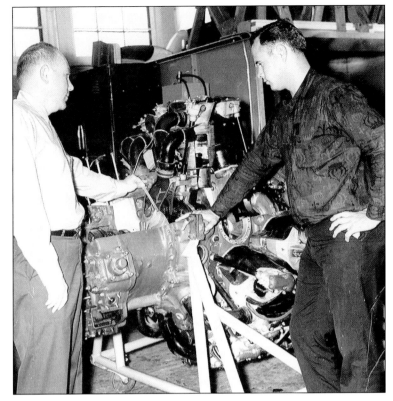

Lake Area Technical Institute was involved in ethanol-powered aircraft research in the late 1990s. Shown here from left to right are South Dakota State University professor Dr. Dennis Heller, project principal investigator; Greg Klein, Lake Area Technical instructor and project mechanic; and Jim Behnkin, project director and chief pilot. This aircraft is the first certified to fly with fuel ranging from 100LL to an 85 percent aviation ethanol blend. (Courtesy of Lake Area Technical Institute.)

The graduating class of 2003 is pictured on tour at the South Dakota Air National Guard base engine overhaul test facility in Sioux Falls. The F-16 engine is being tested after overhaul, in preparation for installation in an aircraft. (Courtesy of Lake Area Technical Institute.)

South Dakota State University has had intermittent programs for pilot training since the Civilian Pilot Training Program of the 1930s. The current program started in 1999 and offers a bachelor of science degree with three areas of specialization: aviation education, aviation management, and aviation maintenance management. In 2009, eighty-five students were enrolled. Since 1999, approximately 50 percent of graduates are employed in the aviation field. (SDSUAP)

Seven

AVIATION GETS PERSONAL

The preceding six chapters in this book attempt to chronicle the development of aviation in the state during the last 100 years and show that, for most people, aviation is a business. The business might be transportation or it might be war. However, for many South Dakotans, aviation is all about fun, pure and simple.

Mutual interest groups such as the Flying Farmers and Ranchers combine work and fun. Ranchers can quickly check their cattle by plane and have more time for other tasks. The organization lets them share their love of farming and flying with other like-minded pilots.

The Ninety-Nines strive to give support to female pilots across the state. Women have always played a minor role in aviation in the state, much like the rest of the country. However, they have a passion for flying that cannot be extinguished.

Chapters of the Experimental Aircraft Association provide resources and encouragement to people who would rather build and fly aircraft of their own making. Not until the federal government set up rules for aircraft certification for homebuilt aircraft was there a need for such an organization. People built their own planes long before this, but they were not necessarily safe or airworthy.

The Civil Air Patrol started out during World War II to allow civilian pilots and their planes to help with the war effort. However, at the end of the war, the organization found new missions in air search and rescue, aerospace education, and a cadet program. CAP continues serving South Dakota with squadrons and aircraft.

The South Dakota Pilots Association provides advocacy for the state's pilots. There are also all sorts of people who want to test themselves by performing for the public or competing in aerobatics or races. The real meaning of flying is fun! Let us hope that in another 100 years that is still the real meaning.

Charter

To All To Whom These Presents Shall Come,

Greeting:

It is hereby Certified that the **South Dakota** State Flying Farmers Association, having complied with the requirements for membership as outlined in the Articles of Incorporation and By-laws of the

NATIONAL FLYING FARMERS ASSOCIATION

is hereby granted membership in said national association, subject to such rules, regulations, restrictions and limitations as may from time to time be adopted by the Board of Directors or committee authorized thereby.

IN WITNESS WHEREOF, This charter has been signed by the president, attested by the secretary and the corporate seal hereto fixed this 11th day of NOVEMBER, 1946.

Forrest E. Watson
President

Attest:

Bert A. Hanson
Secretary

The South Dakota Flying Farmers and Ranchers was organized in 1946 and received a charter from the International Flying Farmers organization that year. Its purpose was to share farming and ranching techniques, as well as fellowship. The group held fly-ins all over the state. The 1963 International Flying Farmers convention was held in Rapid City with 350 planes and 1,200 people attending. (Courtesy of Connie Geide.)

By 1948, the South Dakota Flying Farmers provided felt patches for clothing and decals for planes. The group grew quickly, and William Piper of Piper Aircraft flew a Tri-Pacer to the state convention in Spearfish in 1951, where he was made a life member. The same year, the South Dakota State Fair asked the group to sponsor a fly-in. (Courtesy of Connie Geide.)

The Flying Farmers started a new tradition in 1951 by having a state queen. The first was Dorothy Woodward from Long Valley. She flew her Stinson Stationwagon to the National Convention in Fort Worth, Texas, that year and was also elected South Dakota state president. Each of the five state districts sponsored a fly-in. (Courtesy of Connie Geide.)

In 1950, the Flying Farmers asked the South Dakota Aeronautics Commission to produce a state aeronautical chart showing farm runways. The 1953 map showed farms and cost 50¢. Today all South Dakota pilots receive a color map as part of their annual aircraft registration. With dwindling membership, the South Dakota chapter merged with North Dakota's and Minnesota's in 2005, forming the Minnkota Chapter. (Courtesy of Connie Geide.)

Nellie Zabel Willhite was more than the first female pilot in South Dakota. Nellie lost her hearing from measles as a child, so she was also the first deaf person to earn a pilot's license. Jacqueline Cochran asked her to fly for the British Air Transport Auxiliary and the Women Airforce Service Pilots. However, Nellie taught ground school to military pilots at Hill Army Air Force Base. (Courtesy of Marilyn Madison.)

Nellie Zabel Willhite was a founding member of the Ninety-Nines, International Organization of Licensed Women Pilots. In 1941, she started the first South Dakota chapter. This probably represents all of the women in the state in 1941 who had a pilot's license. That chapter was succeeded by three other chapters over the years. Few female pilots and great distances hamper chapter success. (Courtesy of Marilyn Madison.)

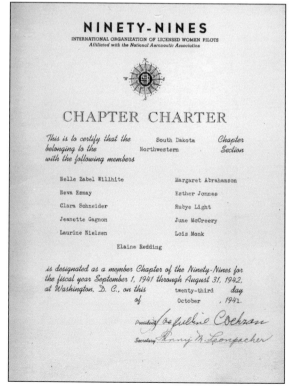

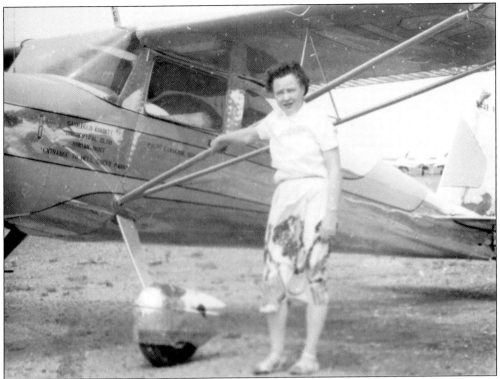

The Ninety-Nines are best known in aviation circles for their "Powder Puff Derby," correctly known as the All-Woman Transcontinental Air Race. The races started in 1947 and continued until 1977. Dorothy Lee, a pilot and flight service specialist based at the Rapid City Flight Service office, competed with her Cessna 140 in 1959. Today the race is called the Air Race Classic. (Courtesy of Luverne Kraemer.)

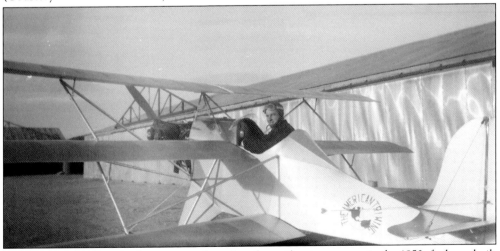

The Civil Aeronautics Authority created an aircraft certification process in the 1950s for homebuilt airplanes. The first South Dakota homebuilt airplane certified under the experimental category was Luverne Kraemer's American Triwing that he completed in 1952. This is the plane and pilot at Halley Airport in Rapid City. In 1953, the Experimental Aircraft Association was started and Kraemer was member No. 72. (Courtesy of Luverne Kraemer.)

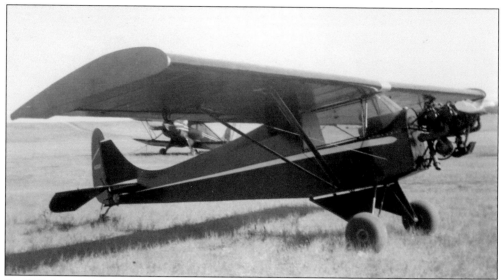

By 1953, Luverne Kraemer had built and certified the second homebuilt in the state, his "Rapid Rambler." It was a single-seat plane similar to a Piper J-3 Cub. It had a 24-foot wing span and an empty weight of 400 pounds. It cruised at 100 miles per hour, with a landing speed of 30 miles per hour. (Courtesy of Luverne Kraemer.)

Luverne Kraemer completed his third homebuilt in 1964, a modified Stits Playboy. It had a 21-foot, 10-inch wing span and an empty weight of 708 pounds. Gross weight was 1,050 pounds. It cruised at 120 miles per hour with a landing speed of 70 miles per hour. It needed 300 feet of runway for takeoff and landed in 500 feet. (Courtesy of Luverne Kraemer.)

Black Hills Chapter 39 of the Experimental Aircraft Association formed in 1963. Meetings were held in Luverne Kraemer's basement, where members could observe progress on his Stits Playboy. Pictured from left to right are (first row) Glen Anderson, unidentified, unidentified, Jack Tyrell, and David Eatherton; (second row) Jim Shy, Wayne McAfee, Ken Post, Carl Schroeder, unidentified, Merwyn Moore, Maurice Haden, and unidentified. Other EAA chapters are in Sioux Falls, Yankton, and Spearfish. (Courtesy of Luverne Kraemer.)

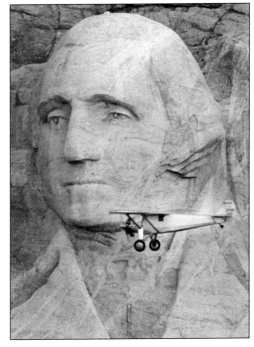

To commemorate Charles Lindbergh's tour of America in 1927, the Experimental Aircraft Association built a replica of the *Spirit of St. Louis* in 1977. It visited Rapid City and Sioux Falls and did a flyby of Mount Rushmore. Black Hills Chapter 39 and Sioux Falls Chapter 289 were hosts for the public events in Rapid City and at Tea Airport near Sioux Falls. (Courtesy of Marion Havelaar.)

Dan Benkert and his homebuilt Starduster with a "Young Eagle." The Experimental Aircraft Association's Young Eagles program, started in 1992, gives youth ages 8 to 17 the opportunity to fly in general aviation airplanes free of charge, through the generosity of EAA member volunteers. Dan is a member of EAA Chapter 39 in Rapid City. (Courtesy of Norma Kraemer.)

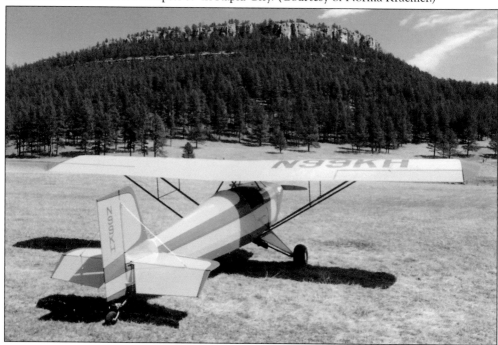

Norma (Hellmann) Kraemer was the first woman to build her own airplane in South Dakota. With Luverne Kraemer as her mentor, she built a Corben Junior Ace from blueprints over a three-year period, completing it in 1993. It is powered by a Continental 85-horsepower engine. She was also the test pilot. While Norma built one airplane in this time period, Luverne rebuilt three. (Courtesy of Norma Kraemer.)

Civil Air Patrol continued after World War II and has squadrons in many towns in the state. They provide air search and rescue for the U.S. Air Force as its official auxiliary. CAP meets several times a year at airports around the state to train using aerial search and rescue techniques. This is a view of a target during a SARTEST at Hot Springs, South Dakota, in 1978. (Courtesy of Norma Kraemer.)

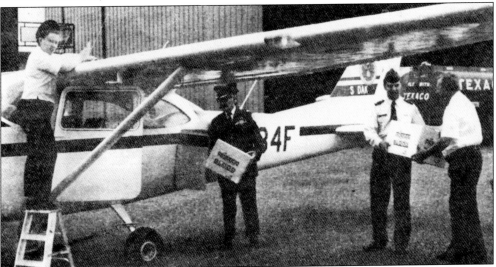

Besides looking for downed airplanes, Civil Air Patrol also uses air and ground crews to help the public. In the 1970s and 1980s, CAP delivered blood for United Blood Services to hospitals in South Dakota, Nebraska, and Wyoming. Pictured here from left to right are Norma (Hellmann) Kraemer, Frank Fife, David Winters, and Jim Draper preparing for a flight to Mitchell, South Dakota. (Courtesy of Philip McCauley.).

Civil Air Patrol has several airplanes assigned across the state. This Cessna 172 hosted by the Rushmore Composite Squadron was displayed at an Ellsworth Air Force Base open house in 1982. CAP promotes a cadet program for young people, flies forest fire spotting missions, and tracks mountain lions, now in state-of-the-art Cessna 182s. (Courtesy of Norma Kraemer.)

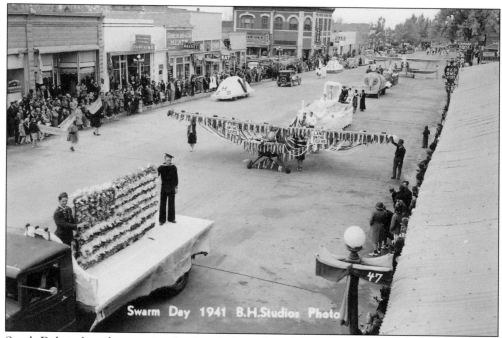

South Dakota has always enjoyed using airplanes for celebrations. This is the 1941 Swarm Day parade in Spearfish, with a TC Aeronca in front and a UPF 7 Waco at back parading down Main Street. The Waco is running under its own power. (Courtesy of Cecil Ice.)

Ercoupes arrived in force for this 1950s fly-in at Halley Airport in Rapid City. Fly-ins have always been popular, especially during warm weather, when they are frequently held on weekends, often with an associated pancake breakfast. (Courtesy of Marion Havelaar.)

Pictured from left to right are Luverne Kraemer's Curtiss Pusher, Floyd Hesler's Alexander Eaglerock, and Maurice Haden's Nicholas Beasley at Halley Airport in 1955, with a South Dakota Army National Guard helicopter in the air. Nellie Zabel Willhite was original owner of Hesler's plane; he found it in a pig barn at Plankinton and restored it. The plane is now in a museum in Huntsville, Alabama. (Courtesy of Luverne Kraemer.)

Marion Havelaar flew first-day cover mail to the South Dakota Centennial wagon trains in 1989. One wagon train started at Elk Point and picked up the mail at Vermillion. It then ended at Huron at the state fair. The other train started in Philip and ended at the Fair. Marion flew his restored 1931 Waco starting in Rapid City, going to Pierre, Vermillion, and Philip. (Courtesy of Luverne Kraemer.)

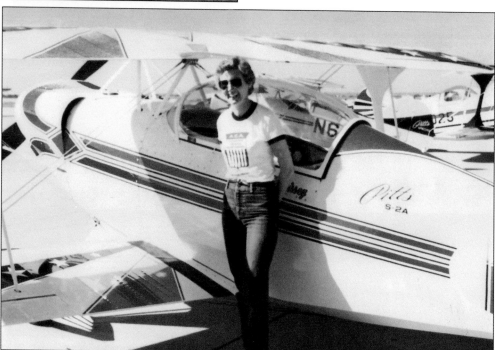

Nettie Myers (Sanchez) of Sioux Falls was first woman to win top honors at the U.S. Aerobatics Championships in 1979 in the sportsman category. This also made her the first South Dakotan to win at this competition. She worked hard to earn this honor. She earned her pilot's license in 1976 and won the Aerobatics Championship in just three years of flying. (Courtesy of Nettie Myers.)

Women flying for scheduled airlines in the United States were slow in coming to South Dakota. Joy Geide Hohn flew for Great Lakes Airlines in a Beech 1900 in 1991. As a child, she was active with her family in the South Dakota Flying Farmers and Ranchers and was encouraged by her parents, Earl and Connie Geide, to earn her pilot license as a teenager. (Courtesy of Connie Geide.)

The Vanguard Flying Team flew at the Sioux Falls Airshow in 1986. Marv Randall and Earl Hovdenes built and flew RV-3As and operated as Randall Aviation. By 1993, their team had expanded to use four airplanes called the Vanguard Squadron. This unique aerobatic team of homebuilt aircraft uses 100 percent ethanol, not gasoline, to power its planes. (Courtesy of Marion Havelaar.)

This South Dakota-themed Cirrus officials' plane for the 2008 AirVenture Cup is on the ramp at Oshkosh, Wisconsin. The 2008 race started in Mitchell and finished at the world's largest fly-in, AirVenture. The race originated as a Kitty Hawk, North Carolina, to Oshkosh event in 1998, but Mitchell began alternating as the starting point with Dayton, Ohio, in 2008 to draw more western pilots. (Courtesy of Norma Kraemer.)

The 2008 AirVenture Cup had 45 competitors plus support aircraft. Mitchell hosted, with help from the South Dakota Aeronautics Commission; the fixed based operator in Mitchell, Wright Brothers; and the South Dakota Pilots Association and Experimental Aircraft Association chapters from Rapid City and Yankton. Rainy weather delayed the start, but the race was still a big success. (Courtesy of Norma Kraemer.)

The South Dakota Pilots Association set up an information booth at the AirVenture Cup in Mitchell in 2008. Pictured from left to right are Janet Rathbun; president Grove Rathbun; executive director Steve Hamilton; and director David Cwach. The SDPA was started in 1993 to monitor government actions concerning aviation. It sponsors flying and mechanics training scholarships and publishes a bimonthly newsletter. (Courtesy of Norma Kraemer.)

In 1978, a group of real estate developers built a residential airpark, Black Hills Flyway, south of Hot Springs on U.S. Highway 71. They built a 4,200-foot-long runway and subdivided the surrounding land into 120 lots of 5 acres or more. Three lots were sold, but the real estate interest rates of the era doomed the project. It disappeared from aeronautical charts by 1999. (Courtesy of Bryce Nelson.)

The premier air race in the world is held at Reno, Nevada. South Dakotan Doug "Jethro" Bodine has competed in the Formula 1 class since 2006, when he qualified for the gold division and earned eighth place. He has finished as high as third and plans to continue. Doug started competing while a B-1 pilot at Ellsworth Air Force Base. (Courtesy of Doug Bodine.)

Doug Bodine races *Yellow Peril*, a highly modified Cassutt III. It is powered by an O-200 engine, has a top level speed of 255 mph to date, and is dive-tested to 320 mph. Ground crew includes Brad Docken, Doug Kotinek, and Kyle Wilson. Retired from the U.S. Air Force, Bodine flies as an air ambulance pilot for Dale Aviation in Rapid City. (Courtesy of Doug Bodine.)

Jim Peitz grew up flying across South Dakota's plains with his father. The learned passion for flying led to his pilot's license in 1975; by 1989, he had his own fixed based operation in Pierre. This Christen Eagle started his self-taught aerobatics career in 1992. Jim reports that the ability to control an aircraft that seems totally out of control is the pinnacle of his flying. (Courtesy of Jim Peitz.)

Since 1997, the Extra 300L was Jim Peitz's performance aircraft. He has performed for millions of air show fans throughout North America. Jim's cutting edge style of unlimited aerobatics, including gyroscopic and tumbling maneuvers, defines him as a top aerobatic performer in the United States. Jim was elected to the International Council of Airshow's board of directors and served as chairman of the board. (Courtesy of Jim Peitz.)

DISCOVER THOUSANDS OF LOCAL HISTORY BOOKS FEATURING MILLIONS OF VINTAGE IMAGES

Arcadia Publishing, the leading local history publisher in the United States, is committed to making history accessible and meaningful through publishing books that celebrate and preserve the heritage of America's people and places.

Find more books like this at
www.arcadiapublishing.com

Search for your hometown history, your old stomping grounds, and even your favorite sports team.

Consistent with our mission to preserve history on a local level, this book was printed in South Carolina on American-made paper and manufactured entirely in the United States. Products carrying the accredited Forest Stewardship Council (FSC) label are printed on 100 percent FSC-certified paper.

MADE IN THE USA